CREATIVE APPROACHES TO PHOTOGRAPHING PEOPLE

CREATIVE APPROACHES TO PHOTOGRAPHING PEOPLE

Vincent Colabella

AMPHOTO
an imprint of Watson-Guptill Publications/New York

Vincent Colabella is a professional photographer who lives and works in New York City. He holds a Bachelor of Fine Arts with honors from the Pratt Institute in New York, where he studied under such photographers as David Langley, Roman Vishniac, and Emmet Gowin.

A specialist in portraiture, Colabella's work has appeared in such magazines as *Harper's Bazaar, Forbes,* and *Folio.* His corporate clients range from AMF/Head sports equipment to Warner Communications.

Exhibitions of Colabella's work have been held at the Pratt Gallery and the Adagio Gallery in New York.

Editorial concept by MARISA BULZONE
Edited by BARBARA KLINGER
Designed by ARETA BUK
Production Manager: ELLEN GREENE

First published 1986 in New York by AMPHOTO, an imprint of Watson-Guptill Publications, a division of Billboard Publications, Inc., 1515 Broadway, New York, NY 10036

Library of Congress Cataloging in Publication Data

Colabella, Vincent.
 Creative approaches to photographing people.

 Includes index.
 1. Photography—Portraits. I. Title.
TR575.C64 1986 778.9'2 85-28715
ISBN 0-8174-3714-2
ISBN 0-8174-3715-0 (pbk.)

Manufactured in Japan

1 2 3 4 5 6 7 8 9 / 91 90 89 88 87 86

Dedication This book is dedicated to my father—and best friend—Vincent Colabella, my mother, Connie Colabella, and Nina. Very special thanks to Marisa Bulzone, whose faith in my work is appreciated, and to all of the sitters who consented to be a part of this book.

The contemplative pose and expression of Helen Lee, editor of Hamptons *magazine, dominates the portrait, even though much of the surrounding environment is included. Skylights above and a wall of windows directly in front of Helen provided natural lighting.*

PREFACE

In the pages that follow, I will be presenting a selection of photographs of people, and explaining how and why each was created in a given manner. Some of these are photographs that were taken for a specific purpose, such as an advertisement or magazine illustration, while others simply serve as straightforward portraits of individuals. However, each has in common the reflection of individual characteristics on the part of the subjects and personal style on the part of the photographer.

While the technical information on how each picture was taken is included, I believe that the intellectual considerations involved in these situtations should be the overriding concern surrounding any photograph of a person.

I hope to present my own thought process regarding portraiture, explaining what is important in my work and why, and relating my use of the mind's eye to translate thought into two-dimensional form. A photograph is like prose; it begins with an idea, which is then developed and eventually executed. This is not a quick process, but it can be a methodical one. Any artist develops an idea or concept into a finished product and the photographer is no different.

I follow certain rules and procedures in the creation of my portraits, using outlines, notes, and sketches. Other methods of research and preparation may be valid, but this is the one I use. Some photographers use a totally spontaneous approach to the subject, but I do not. I feel that research is an important exercise, one that enables the photographer to give the viewer as much information as possible. In this way, the viewer gains insight into the subject's personality through the portrait. I try to transform my portraits from mere physical representations to more natural, visual descriptions of the subject at hand.

The subject plays an important part in this process, and in order to be able to truly capture the person, the photographer must keep an open mind and take an objective view of the sitter. The resultant photographs should be a combination of the photographer's unbiased reaction to the subject and his or her creative input into the image.

It is the photographer's creativity, not the photographer's equipment, that ultimately produces the photograph. As you begin to develop your own creative approaches to photographing people, I hope you will find that the mind is the most important tool used in creating a successful portrait.

My brother, George Colabella, is a fund raiser for non-profit organizations. I wanted to photograph him in his shirtsleeves to emphasize his hard-working, determined side. Shot straight on, with natural light and strobe combined to knock out the shadows, the photograph achieves a natural and open look. I moved in for tight cropping to take a powerful shot of his penetrating eyes, but still retained some of the background to ease the tension around the face.

INTRODUCTION

Portraiture, in one form or another, has existed for thousands of years. Before the invention of the photographic process, it took a great deal of time and money to have one's image preserved by a painter or sculptor. Only the elite could afford a portrait.

The advent of photography in the mid-1800s brought the process of recordings one's image to the masses. Now anyone could afford a portrait. All that was required was a couple of minutes of sitting absolutely still and a couple of days to get the image back. Because photography was still in its infancy, the process was extremely slow. In fact, special tools for portraiture included a chair with a head clamp to keep the sitter still.

People flocked to the portrait photographer to have their images recorded. For the first time, an image of oneself was affordable. Cheap portraits, aided by competition, were priced as low as 25 cents.

Each of these images was actually just a photographic record of the particular person seated in front of the camera and little more. Rarely was any effort made to bring out the attitude of the sitter. In fact, the length of time needed to make an exposure all but prohibited anything but a stiff expression on the part of the subject. Despite this, family albums became the vogue and no Victorian home was complete without one.

As time went on, the photographic process became faster and more flexible, and with this advance in technology, the parameters of the photographic portrait also grew. Artists became drawn to this new medium, and they began to investigate photography in terms of its interpretive power.

The Victorian era did have expressive portrait photographers, such as Nadar, Mathew Brady, and Julia Margaret Cameron, but it was not until the turn of the century that photographic portraiture as we know it today began to develop. Edward

Steichen brought the portrait into the realm of commercial photography as his work began to appear in such magazines as *Vanity Fair* as well as in numerous advertising campaigns. Steichen's work, along with that of Cecil Beaton's for *Vogue*, brought new meaning to the photographic portrait as a commercial art form. Their photographs set the groundwork for such photographers as Halsman and Richard Avedon and many other generations of portraitists to come.

Today, the image conjured by the term "photographic portrait" can be as far-ranging as the studio on the corner that specializes in high-school graduates and wedding parties to the startling realism of a Diane Arbus or the fascinating character studies created by Arnold Newman. Whether a portrait is created for private use or for a celebrity endorsement of a commercial product, people remain one of the camera's most interesting subjects.

Perhaps one of the reasons for this is the individuality of each sitter, which allows the photographer the freedom to work with a never-ending variety of subject matter. The ability to develop a unique interpretation of each new personality is essential to truly creative portraiture.

An effective portrait should not only show the physical characteristics of the sitter, it should also show the personality. It is the photographer's job to tell the viewer exactly what the subject behind the collection of physical traits is like. By including props, using the proper lighting, capturing the right pose and expression, and inciting the correct response to the camera, the photographer helps to bring the personality of the subject into focus.

The actual portrait session should be a collaborative effort between the photographer and the subject, with each bringing to the session a preconceived notion of what the eventual portrait will look like. For the subject, the aim is to put his best

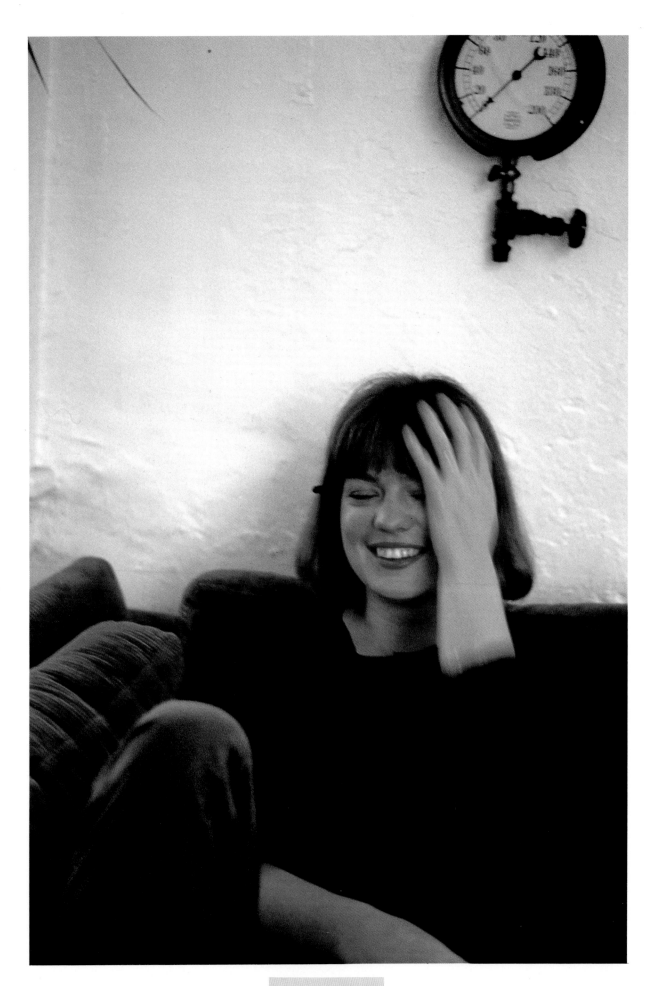

*By including various
visual information, the
photographer helps the
viewer to decipher the
sitter's personality. In
this relaxed, whimsical
portrait of Ann Neu-
man, I chose to keep the
pressure gauge above
her head. The im-
promptu smile indicates
her levity and suggests
"blowing off steam."*

face forward, so that the audience can see him as he wants to be seen. Some photographers may be content to go along with this, simply lighting the subject in the most flattering manner and snapping a pleasing expression and pose. But a photographer who is interested in the actual art of portraiture will go beyond this and participate in the session with interest equal to that of the subject.

Two photographers can use the same equipment and work with the same subjects, but the resulting portraits will be entirely different because of the elements of style that the individual photographer has brought to that session. For the photographer, these elements include thought, a strong concept, and the ability to be flexible and accept chance occurrences.

Take the time to research your subject. If conditions allow, try to get to know the subject as a person. After all, if you have taken an interest in portraiture, it should follow that you like people, or at least find them interesting. A preportrait interview need not take a lot of time—often you won't have that luxury, and you must try to clue yourself in on the key elements of the personality in five or ten minutes. But this is usually all the time you need to pick up the subject's basic traits. This time spent before you start setting up, or even while you're setting up, will not only serve to introduce you to the subject, but will also help the person being photographed to relax. Portrait photography is like telling a story. You must present the viewer with pertinent facts about the sitter. Include enough information so that your portrayal is as complete and honest as possible.

The photographic portraits that you produce will then be well-planned and well-executed documents of your subjects, successful because of their content and not your technical skills. The more information given by the photographer about the subject, the greater the possibility of an insightful portrait.

Chance in photography is for amateurs, and consistency is only achieved when a professional has mastered the tools of the trade. Thorough testing of your equipment allows the spontaneity of the session to become your only variable.

EQUIPMENT

It is important to know what you will come away with technically as well as conceptually. Chance is for amateurs. Every knowledgeable professional knows 99 percent of the time what he will be getting back from his work. That is not to say that there might not be minute little differences or surprises, but these "surprises" will not have an effect on the interpretation of the final photograph.

To be able to previsualize, you must have as firm a grasp on your materials and tools as you have on your artistic vision. You know what your final print will look like not only from what you are seeing before your eyes but also from your familiarity with the technical ingredients of a photograph. To be able to do this is to be able to call yourself a professional. Professionals come away from a shooting with results, consistently and without faltering. Their clients are able to look at their portfolios and give them a job knowing that they will get a photograph representational of the work they have seen. This consistency ultimately becomes your signature, and that is what clients will come to you for.

The first step in controlling technical results is to find the film you prefer to use. Then continue using the same film so that you begin to see consistent results.

Practice shooting various films in one mode, then another, until you achieve the results you are looking for. Record the data so you have a reference available. The data should include film type, camera, lens, lighting, f/stop, shutter speed, and distance from the subject. Once you achieve the desired results, you will want to duplicate them until the technical aspects become second nature, so keep using the same film. The last thing you want to do is to switch films for every picture. Although different films may give different effects (and this is acceptable at times), what you are after now is a consistent look. In science, this might be considered the control of the experiment. The variable of the experiment is your subject and his environment. Your creative concern is with your subject, not with your technique.

Choose the equipment that you feel most comfortable with and work with it until the operation of your camera becomes second nature. Remember, the camera only captures what you choose to photograph. The ultimate creative result lies with the photographer, regardless of the type of camera used.

Cameras

and

Film

In choosing a camera, your main concern should be in finding a camera and format that you are comfortable with. For portraiture, any well-designed 35mm or 2¼″ × 2¼″ single-lens reflex camera is suitable.

The 35mm camera provides a rectangular format; the 2¼″ × 2¼″ camera, a square format. The 2¼″-square format is, of course, larger, which means that the quality of the image will be finer. For

The choice of film is probably one of the most important decisions that a photographer makes. Find a film you like and stick with it. Test it until you know exactly how it will perform under a variety of conditions. This will help you to achieve consistency in your photographs—and avoid costly mistakes.

color work, where film grain is less of a problem, the difference in image size does not greatly affect the quality of the final print, and I use both formats. For black-and-white photography, however, the image size can make a significant difference in print quality, and I always use the larger 2¼″-square format. My personal preference, therefore, is for the 2¼″-square camera, although I find the 35mm camera an excellent tool for color work.

In choosing film, you should be aware that the greater the film speed (ISO), the greater the graininess. I rarely use a film faster than Plus-X (ISO 125) for black-and-white photos or a film faster than Kodachrome 64 or Ektachrome 100 for color. Kodachrome 64 is made for 35mm cameras; Ektachrome 100, for 2¼″-square (120 roll film) cameras. Both films yield superb details and excellent color, and both are reliable.

There are two main systems of artificial lighting available. One is strobe light (electronic flash) and the other is incandescent light, which includes quartz lamps and tungsten bulbs. Each system has its own particular advantages and disadvantages.

Incandescent lighting has two main advantages over strobe. One is that the lamps are considerably less expensive than the strobe units. The other is that, unlike strobe (which provides a brief flash of light), the incandescent lamps provide a constant source of light. As a result, you can see precisely how the highlights and shadows fall on your subject as you set up your situation. With strobe, it is difficult to judge the exact effect you will get.

Incandescent light, however, has several disadvantages. In the first place, it is much less powerful than strobe. This means that you must increase the exposure time by using slower shutter speeds and/or larger apertures. As a result, you may have to sacrifice the ability to stop the action or to obtain background definition. In addition, light from incandescent lamps (even those that are color balanced at 3400° Kelvin for use with daylight film) cannot be successfully mixed with natural daylight when you are using color film. Finally, the incandescent lights usually get quite hot and may make your sitter uncomfortable.

Strobe has two major advantages. First, by combining high intensity and brief duration, strobe allows you to freeze the action and to use smaller apertures. Second, strobe light closely resembles the color quality of natural daylight so that the two are compatible even for color work.

I personally prefer to use strobe lighting; for me, its benefits outweigh its disadvantages, and I consider the system well worth its premium price. I like having the freedom to mix artificial light with daylight as well as having the opportunity to freeze action such as spontaneous gestures and expressions. I also like being able to stop down to *f*/8 or more to obtain sufficient depth of field.

The difficulty of being unable to judge precisely where the light will fall on your subject can be handled in two ways. One way is to use the modeling lights built into the strobe units. These are small quartz lights that serve as a continuous light source and will show the general effect you can expect to get. Another way is to take Polaroid shots to test the situation and see what effects you will actually achieve on film. Eventually, you will be able to accurately predict your lighting effects by basing them on your accumulation of experience with various strobe setups.

While strobe lights do not get hot, they might influence the sitter in a different way; that is, the sitter may key himself or herself to the flash sequence and may maintain an artificial pose in response to the expected flash. By not getting into a set tempo while shooting, you can capture the spontaneous movements and achieve a more natural look.

These are some of the accessories that help the photographer control light. By using reflectors and different types of lighting systems, you have the final decision in how your photograph looks. A complete understanding of how each of the various accessories works will allow your photography to be limited only by what your mind can envision.

Reflectors

and Other

Accessories

Both lighting systems have a variety of accessories to provide different effects. A snoot is a tube-like attachment that turns the light source into a spotlight. The bank light, also called a soft box, is a large box with the light source at one end and a diffusion panel opposite, with the remaining inner walls painted white or silver. This box produces a directional but diffuse kind of light such as the light that comes from a window. Umbrella lighting incorporates a light that is shot into a collapsible reflector, which is shaped like an umbrella and also may be coated with silver or white. The reflected light is broad and diffuse. Umbrellas are excellent for

head and beauty shots as they offer up a flattering, shadowless, diffuse light.

You may decide to take your standard light head and point it at a reflector card and have the reflector illuminate the subject. The cast light will be a result of the card you use. White causes a soft light; silver, a harsh light. Gold gives a warm glow; other colors reflect light tinged with the particular color of the card used.

Reflector cards are also used to control shadows created by the main light. Placing a white reflector card near the unlit side of the subject opens the shadow area. Placing a black reflector on the shadow side deepens the shadows.

1

For this portrait of David Schwartz, an architect and potter, I chose to use an environmental approach. I used a long exposure to catch the warm glow of the fire within the kiln, plus a flash to fill in the light and freeze the action.

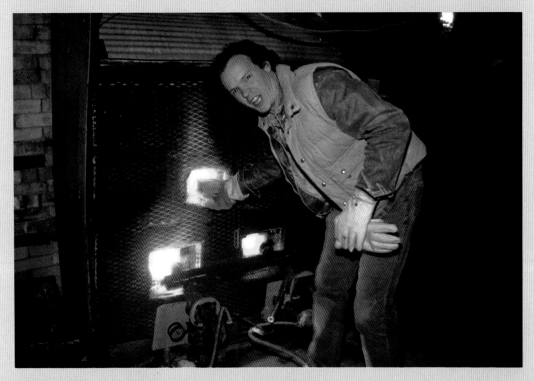

PLANNING THE PORTRAIT

When you are commissioned to shoot someone's portrait, regardless of whether it is for private or commercial purposes, a decision has to be made as to what is to be conveyed by the finished photograph. There will usually be a meeting between the photographer and the client to decide what situation best fits the sitter as well as how much input the photographer has in determining the final product.

Some clients present the photographer with very specific ideas. An art director for an advertising company, for example, may have a layout of the ad or a list of requirements for the photographer to follow. Other clients may present a more general idea. A magazine editor may request a photograph for a feature story and specify only which person to portray and whether to use color or black-and-white. In the first instance, the photographer is given a detailed concept and must find a way to fulfill the specific requirements. In the second instance, the photographer must interpret the general requirements and contribute the specific ideas. Both cases require planning and decision making.

One of the first things to be decided is the background scheme for the portrait. Will you use the sitter's home or office as a background environment, or will you use your studio with flats or sets? Other visual elements to be decided include lighting technique, framing, and camera angle. Technical and psychological elements must also be considered. What film type, f/stop, and shutter speed will you use? Will clothing and make-up be a factor in portraying the individual? How will you draw the most appropriate pose and expression from the sitter? Every element in the photograph should contribute to illuminate the sitter.

Previsualization

Planning is essential to a successful photo session. Part of this planning is your ability to previsualize, to picture in your mind, what the final product is to look like. All situations, if they are to be successful, should be previsualized. You must have your concepts straight so that your actual shooting time can be used for taking pictures, not thinking out a solution. Besides the intellectual reasons for entering a situation with the knowledge of what is going to come out of it, there is also a time factor involved. Most sittings do not allow you time to plan and shoot; they allow you only the time to shoot, usually about ten minutes for a commercial client. So your time is valuable and you must know ahead of time what you are going to do.

In many cases, you can meet the sitter before the actual photo session. Here, you must take the opportunity to observe all you can about the person. Accurate, insightful observation will allow you to prepare a successful concept.

Seeing is the essential tool of every artist, and the photographer is no exception. You learn to see by opening your eyes a little more than usual, by noticing more, by looking harder. Do not take things for granted; examine the situation and make mental notes. Look around; notice what a particular person looks like.

What is the posture, hair coloring, style of clothing, mood? Are the eyes deep set; is the hair combed back? Keep looking and deciphering; you must begin to notice all the nuances of your sitter, as they will key you into the person behind the facial features.

Sometimes you must previsualize the results before you meet the sitter. When this happens, you must research your sitter. Find out as much as you can about the person, either directly (by speaking to the person on the phone) or indirectly (by speaking to a third party, such as the person's secretary). Use this information to prepare your concept. In fact, since it is always better to be overprepared than to be caught short, prepare several concepts. When you do meet the sitter, you can alter one of your concepts to suit the situation.

A sketch is a good starting point for pulling together your concepts. You may sketch in one of two ways—either by actually drawing a visual image or, if you are hesitant to use your drawing skills, by sketching a mental image with words. List items such as arms folded, strong side-lighting, head tilted to the left side, and so on. As you read the list, you will begin to have an idea, a mental picture, of what you want your portrait to look like. You have a previsualized concept.

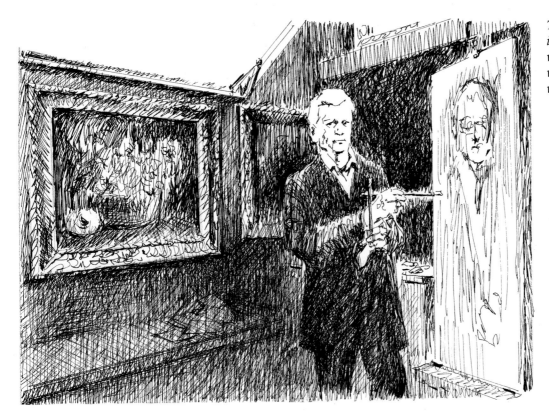

The sketch shows my intent to have the environment translate who the sitter is and what he is about.

Using the

Environment

When you use the environment, your sitter is placed in his or her own confines. Among the person's possessions, there will be an indication of likes and dislikes. What does he hang on his walls, place on his shelves, etc.? Does he have a desk; if so, what is on it, and is it messy or neat? Is his chair easy, soft, and inviting, or is it straight, wooden, and uncomfortable? Is the room generally well-organized, or is it an environmental hazard?

What you are looking for is what the environment says about your sitter. I usually try to include as much information as possible, often using a wide-angle lens.

The more you can include in the frame, the more insight you can give. The environment is an extension of the sitter, and therefore he should be incorporated into it and not randomly placed.

The way to emphasize the sitter is by lighting, focus, and framing. The focus should be on the sitter so that if there is any fall-off of focus, it will occur on the surroundings and not on the subject. The lighting should be keyed on the sitter, with fill-in and subordinate light on the background. It is up to the photographer to decide how much focus and how much light to use.

HERB ABRAMS

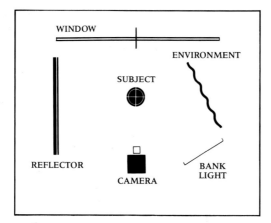

The reason for using the environment is to give an added dimension to the sitter and greater insight to the viewer. When I photographed artist Herb Abrams, I chose to emphasize that his studio is set up to use north light, which is very blue by nature. As a result, the overall look of the portrait is blue. I used the studio's skylight illumination to fill the room and to add a blue cast to this already blue environment. To show Herb Abrams and his work, I chose to fill in with an open light so that everything would be defined. Although the artist uses heavy lighting in his painting, I chose not to mimic it but rather to define it with the open lighting I used.

With the skylight behind the sitter, I placed my light source almost directly in front and balanced the intensity to meet that of the natural light. (In mixing natural light with flash, you determine exposure by considering both light sources. The light is balanced at a 1:1 ratio if the flash-to-subject distance results in an exposure equal to the metered exposure for daylight.) I asked the sitter to hold his brushes and pose beside his work. There seems to be an important link between the sitter's hands and the shape they create and the skylight and the canvases in the studio. There is a union involved—the sitter is in relation to the environment and not placed randomly.

This photograph represents an alternate look at the environment. In the vertical form, the environment shows less essential facts of description, but does have a certain compositional force. The sitter is lost among the elements which are supposed to be subordinate.

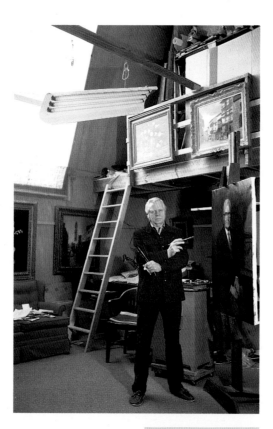

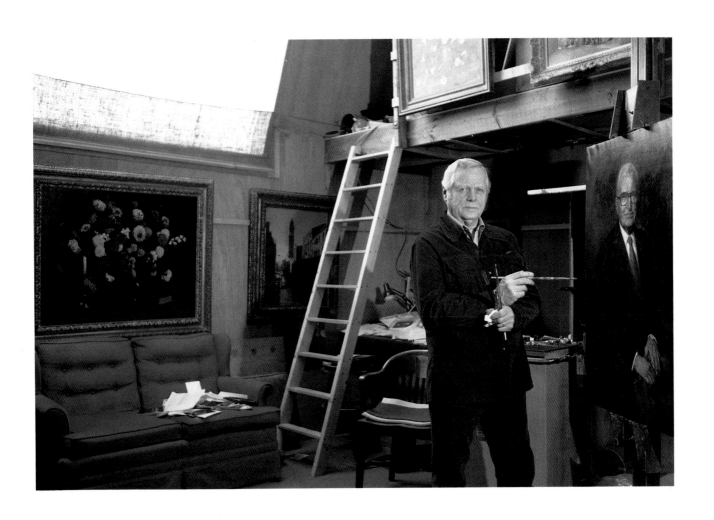

When you use the studio, there is less personal information surrounding the subject. You must exercise more control over the sitter's dress, emotions, and pose in order to inform the viewer. In previsualizing, you should therefore consider the special resources the studio has to offer.

There are multiple lighting solutions available in the studio. On a location shoot, you are generally limited to one or two lighting possibilities merely because of the weight factor in carrying the gear. There are also multiple backgrounds available—simple seamless, Mylar, fabric, or Formica backgrounds, as well as more elaborate sets. With all these variables, however, you must still remember the basic premise of being prepared before the shoot; have a concept set so you are ready for the session.

In previsualizing, don't become overwhelmed by all the possibilities; simply come up with the best solutions in lighting and background for the sitter. In fact, the major reason for using a studio in lieu of a location is its simplicity. This simplicity allows you to bring your subject to the forefront of the picture. When you do this, the lighting, dress, pose, expression, and framing become much more important. You are describing the sitter directly through your control of these elements; you do not let extraneous artifacts describe the sitter to the viewer.

WILLIAM
BARTEE

For this portrait, I was commissioned, privately, to photograph William Bartee, a young on-the-move lawyer. Because it was a private commission, there were no restrictions such as showing the client with his or her new book or invention. I knew Bill to be a high-energy individual whose off-hours were spent jogging, surfing, and having *fun. I also knew he worked hard, long hours and that many of his dealings were with creative people, including a rock-and-roll singer and composer. Since this portrait was a private commission, I was free to capture his more relaxed side.*

Because of his diversity, Bill did not seem to have a real environment of his own; so my first thought was to

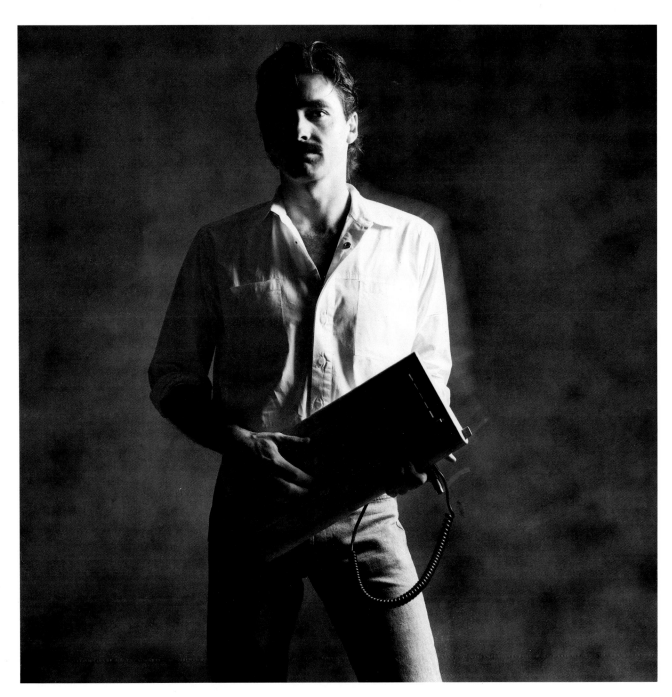

have Bill in a studio setting. I also thought of using a hard sidelight to show his strong character as well as to indicate the two sides of his nature. The brightly lit side symbolizes the clean, working character, while the dark, shadowy side indicates the unknown, personal aspects. The clothes—jeans and a white shirt—also show a dichotomy inherent in the sitter. The modeled background was chosen for its blend of lights and darks and because it works very well with heavy sidelighting.

To give the viewer another hint as to what the sitter was about, I thought of giving him a prop, either from his sporting life or business life. The keyboard of a computer was chosen as a prop to show his business side, but it could also be used in much the same way as a keyboard for a piano is. In fact, as we began to shoot, the keyboard quickly changed into a guitar for Bill, and he began emitting a "James Dean"-like atmosphere. I had set up a situation and let Bill work within it. The original idea was captured, although there were a few minor variations.

My original concept of the portrait was to have the subject using a computer keyboard as if it were a musical keyboard. This case shows how the preplanning can act as a stepping-stone in the development of the final idea. These contact prints show how the session started off mimicking the preconception and how the final portrait evolved by letting the sitter work within the situation.

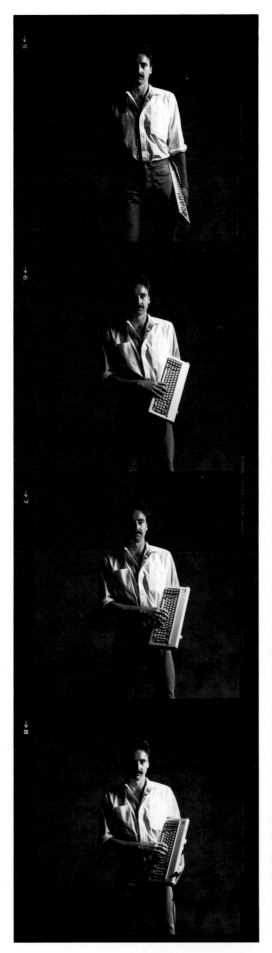
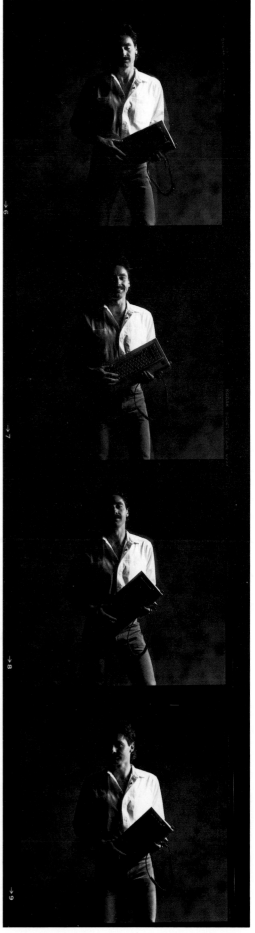

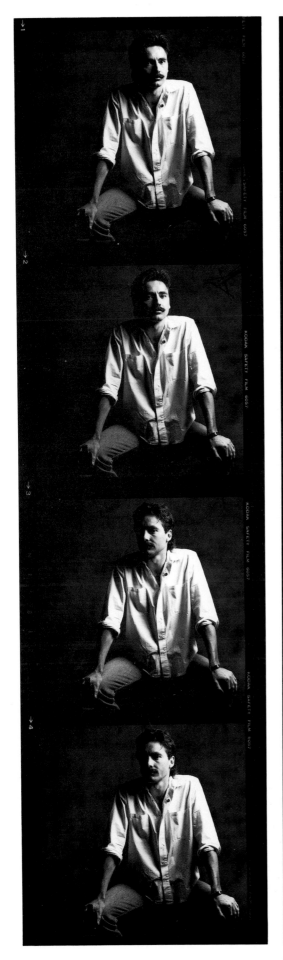

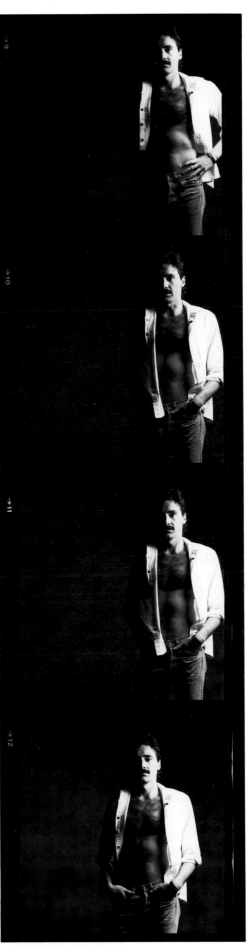

Additional contact prints show photographs taken without the computer as a prop.

NED
EDWARDS

Ned Edwards is one of the top squash players in America. An advertising assignment, for Head sports equipment, called for shooting Ned against a simple black background, so a studio setting was a logical choice.

I completed the requirements for the client (see the poster on the following page), and I asked Ned to stay for additional photographs. Ned projected his ease and self-confidence, and I came away with a contemplative moment of a very self-assured pro who has the physical and psychological tools to be at the top of his field. As it turned out, this photograph was also used in Head's campaign.

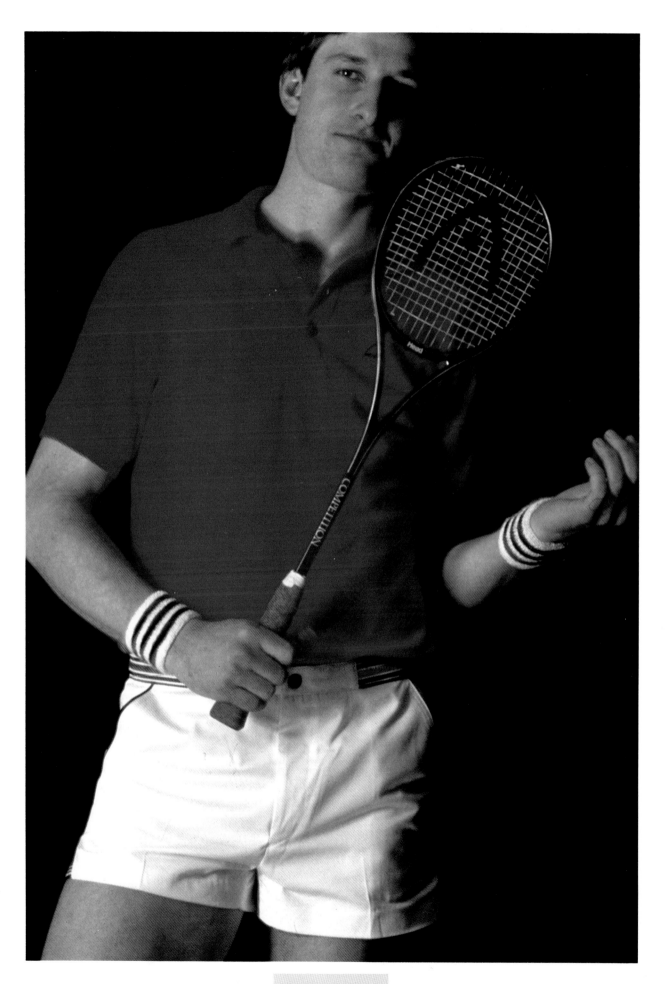

The photograph that was used for this poster emphasized Head's new squash racquet as well as Ned Edwards' prominence as an athlete. Here we see the athlete in motion, stressing both his physical performance and the implied performance of the racquet.

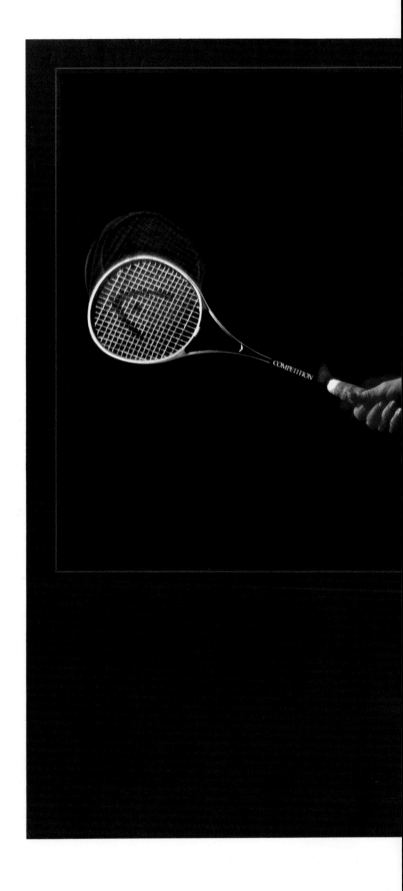

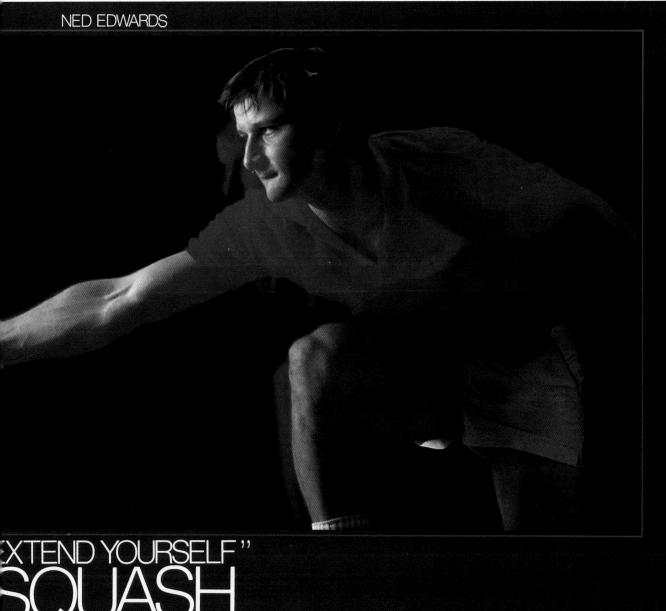

NED EDWARDS

"EXTEND YOURSELF"
SQUASH

HEAD

Make-up

and

Clothing

I believe that special make-up is an unnecessary ingredient for the majority of portrait work. For women, their normal make-up is usually sufficient; for men, no make-up is required. The photograph is a portrait of the person as he or she really is. On occasion, make-up can be employed to highlight a concept, but most often I am after an honest document of my sitter.

In the case of a commercial beauty shot, however, make-up by a professional is a high priority. Here, make-up, applied in varying degrees of intensity, can greatly influence the viewer. Effects can range from the natural look, employing a small amount of make-up, to the more high-fashion look employing many layers.

The common link in all make-up application is that it should stress the eyes and lips. It has even been said that in the past, the subject's eyes and lips were prepared with black make-up to give added intensity to black-and-white portraits.

Clothing should be relevant to the sitter and to the concept of the portrait. I will tell the sitter ahead of time what I prefer as far as clothing is concerned. I don't usually deal in specifics but with whether the outfit is to be casual or formal and whether it is to be light or dark. The sitter will pick out the actual garment, as this will give the viewer another clue to the sitter's personality.

KATHY KEETON

Because this portrait was for a magazine article, it was necessary to achieve a balance between showing who the sitter is and fulfilling an editorial concept. The concept was to portray Kathy Keeton, vice-chairman of OMNI, *in the context of that particular science magazine. The theme was* the exploration of the heavens. To portray this idea, we wanted a modern, almost futuristic outfit.

When the sitter was told about the shot and concept, she was able to come up with the perfect gown, a silver dress which appeared to be from the twenty-first century. To contrast

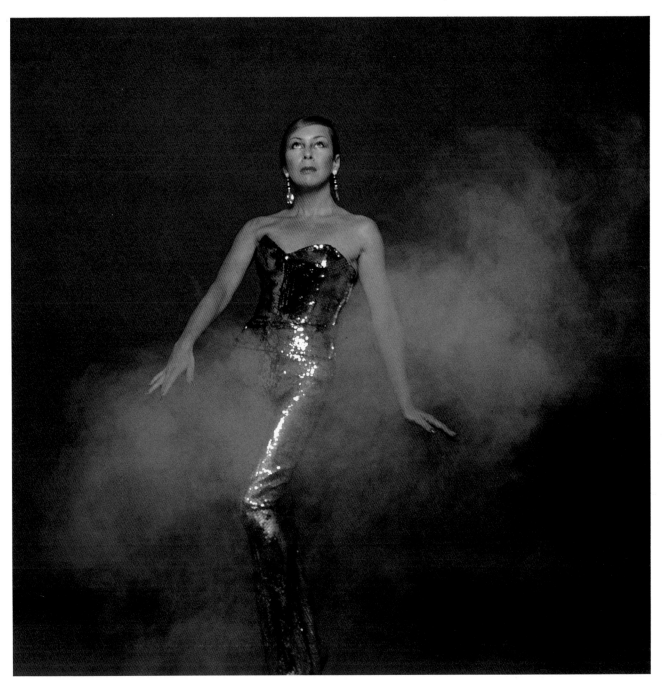

with the light gown and to give the impression of space, I used a dark-blue background. With a rented fog machine, I added mist to the scene, and the resulting effect is as if Kathy Keeton is ready to rise to the heavens. The diagram that I worked out beforehand was especially helpful,

as it indicated to me the direction of the fog.

While the use of make-up shows the influence of our modern concept, it doesn't overpower the results. The photograph, although intended to link the sitter with science, is still attempting to depict a certain person and not just a concept. If we

had gone more high-key, we would have lost the portrait aspect and gained much more concept. There is a delicate balance of concept and sitter—of make-up, dress, and understanding. The outcome was a successful portrait of a specific woman moving forward with her science magazine.

2

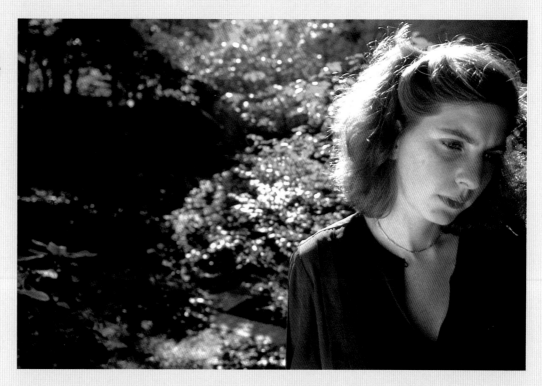

As a poet, Jan Levi deals with abstract ideas; therefore, in this portrait of her, I sought to capture a mood of inward reflection enhanced by the light filtering through the leaves. Placing her at the edge of the picture frame aids the concept.

CONTROLLING THE POSE AND EXPRESSION

The pose and expression of the sitter relays basic information to the viewer. A timid person might shrink, whereas a forceful person will have chest out and head up. The pose and expression should be as natural as possible, as this will ultimately give the viewer some insight into who the sitter is. Occasionally, it is up to the photographer to direct the sitter in a specific area—such as whether to be stern and forceful, in place of sublime and somber. When directed, the sitter will think about what he or she is asked to portray and will work towards that end, adding in his or her personality.

Ninety-nine percent of the time, the sitter will give you what he or she wants portrayed, and it is up to the photographer to draw from what is given. The photograph will become too strained and obtuse if you try to pull out an emotion foreign to the sitter. It is up to the photographer to know enough about the sitter to realize that a pose of forcefulness would be wrong for a timid individual. You must go with what you have and exploit it to the fullest.

Allow the sitter his relaxation and draw from that; work it up to what you want. When your sitter is relaxed, he will be more willing and more open. I usually converse with the sitter and rarely give explicit directions for placement of hands or head; instead, I let the conversation direct the sitter.

Talk about what is familiar to the sitter; have him tell you something about himself. As he is talking, you will notice how he becomes himself and opens up. This is the best opportunity you have to photograph; for it is now that you can record information that tells the story of who the sitter is, through his natural pose and expressions.

JOSEPH MASCIANDARO

With Joe Masciandaro, I originally envisioned a contemplative head-and-shoulder shot. What I wound up with was a full-length shot of Joe and his dog Dr. Zeus sharing a moment together.

My original idea of using a forceful head shot could not work because Joe's personality lends itself to reasoning out a situation, not forcing his beliefs upon it. I decided that I should rethink the idea of the portrait, rather than impose my visual wants. Through deeper involvement with the sitter, I realized that the pose did not necessarily represent him as much as it represented my preconceived notions about him. The concept of the photograph was changed to meet the sitter's actual situation.

Joe was much more relaxed with his friend and companion Dr. Zeus at his side. I allowed Joe to actually direct the photo. As a result, the photograph tells the viewer more about Joe. If I had imposed my original concept, the portrait would have been my interpretation of space, composition, and light—not an interpretation of the sitter.

Allow the sitter the right to be himself; after all, the photograph is essentially about the sitter, not about the photographer or the viewer.

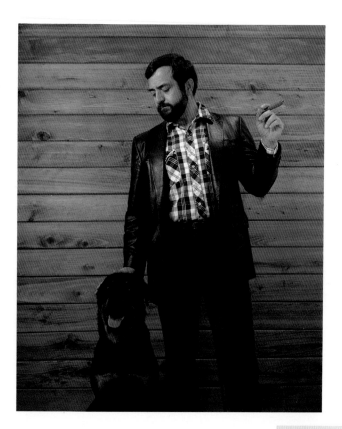

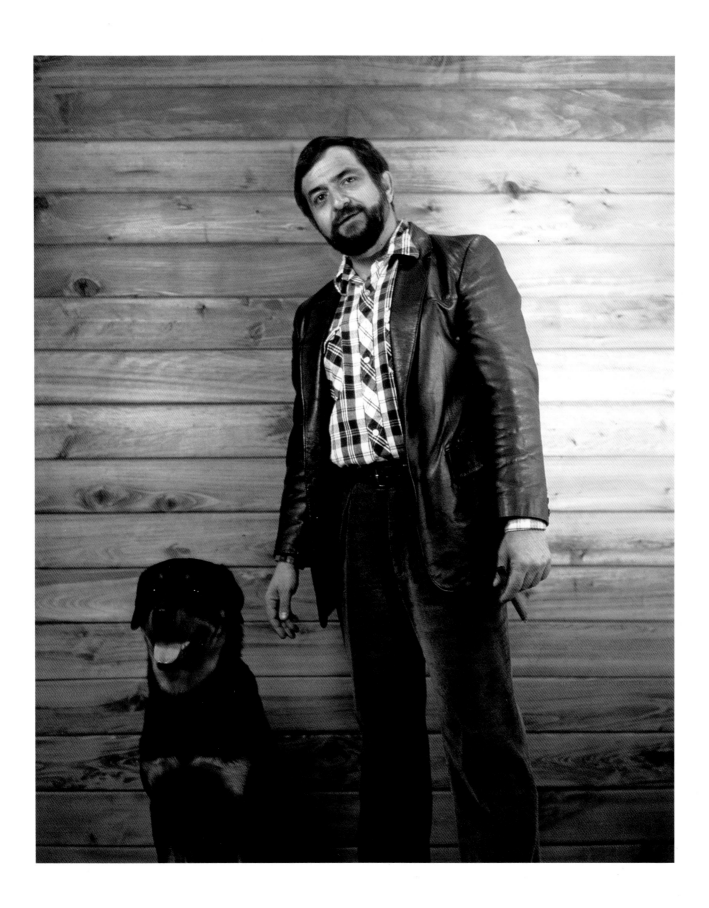

BYRON TEMPLE

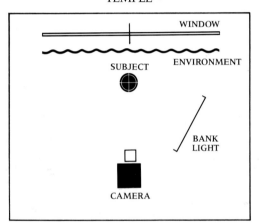

WINDOW

ENVIRONMENT

SUBJECT

BANK LIGHT

CAMERA

Byron Temple is an accomplished artist whose medium is clay. I hesitate to call him a potter, since his work transcends what I might think of as ceramics.

I arrived at Byron's studio, which also incorporates his home, on a cold fall day. The original intention was to shoot him at work and include his working the clay and loading and firing the kiln. During a break, I decided to shoot a more formal portrait.

Instead of shooting in the midst of the work environment, I took Byron off to a calmer area, where I could have more control over what I wanted to portray.

Byron and I chatted about art and politics, and as he got deeper into the conversation, I began firing away. By the end of our shoot, I had captured Byron in a familiar, enlightening moment.

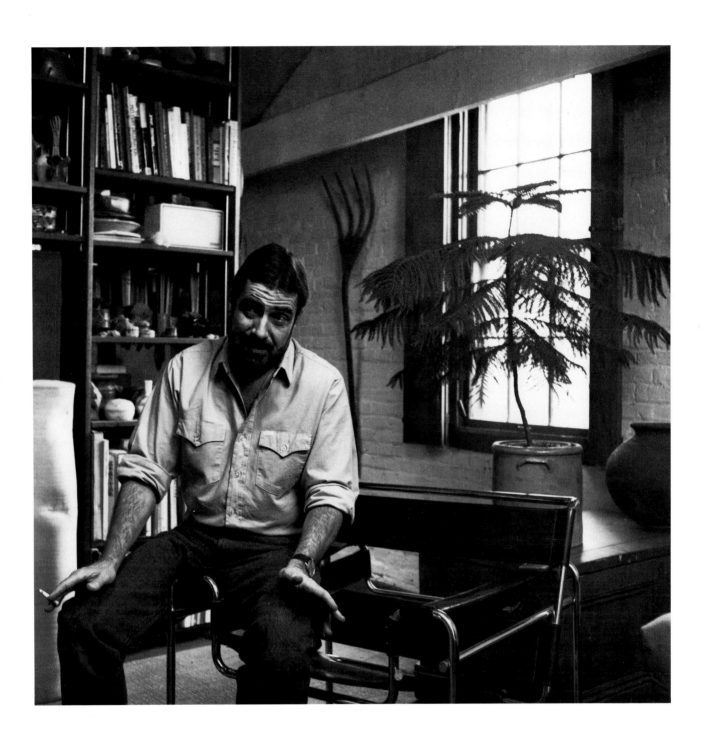

3

The careful placement of gallery owner Elaine Benson amid the objects in her gallery forms a unified composition that stresses her close connection with artists and their work.

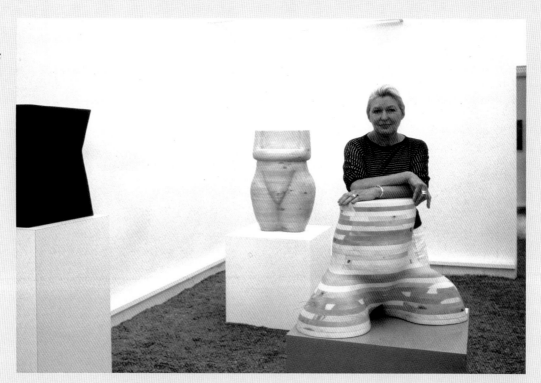

COMPOSITION

Composition is basically a way of visually organizing information. Pictorial composition refers to the way in which the main subject and the subsidiary elements are arranged within the picture space. It is easy to become overwhelmed with the variety of concepts, philosophies, methods, and techniques recommended for achieving good composition. I don't think anyone will challenge the simple fact that there is no single method for learning how to create effective photographic composition. The overriding goal, however, is to achieve a balance of forces within the photograph and create an impression of unity. The viewer should be left with the feeling that nothing could be added to or removed from the picture.

As an artist you must learn to see, examine, and understand what is offered before you shoot. A simple, effective way to begin seeing photographically is to look at things with one eye closed. By closing one eye, you begin to see in two dimensions instead of three. The camera records three-dimensional information and translates it into two-dimensional form. When you begin to look at things without depth, you begin to understand how scale and placement change when objects are forced from three dimensions into two.

By knowing how the camera translates reality, you become more capable of composing a photograph. You learn how the inclusion or exclusion of an object, the height from which you shoot, and the lighting you use influence the photograph. Practically speaking, all of the qualities that make for excellence in life are also those we must use in composition: common sense, self-criticism, and flexibility.

A number of books have been written on the subject of photographic composition and there is always great debate about which principles and concepts will help you to achieve the greatest success. The greatest enemy of philosophy is said to be philosophers. The same holds true of "artists" who tend to make "art" unapproachable. There is a danger in making creative achievement appear to be the domain of only a few. In the end, we learn best by doing.

ROBERT DASH

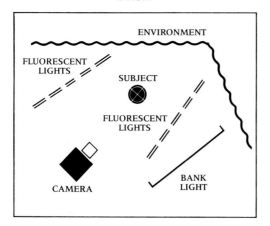

It is easier to comprehend a pictorial composition when it is reduced to a basic dominant geometric shape— a triangle, square, circle, or rectangle. Once the subject matter is enclosed in a neutral geometric shape, a distinct pattern emerges. The dominant shape can be actual or implied. In this photograph of artist Robert Dash, the implied shape is a triangle. Starting with the base line on the floor and moving up to the ashtray on the bench, to the hand with the cigarette, to the pointed finger, and finally to the vent fan at the top of the room, the triangle then moves back down to the slight invasion of the table top on the right side and down the table leg. The implied triangular shape encloses the main element: Mr. Dash.

From this start you can now see other forces of design emerging. The tension between the planes of the flat surface of the ashtray, the up-

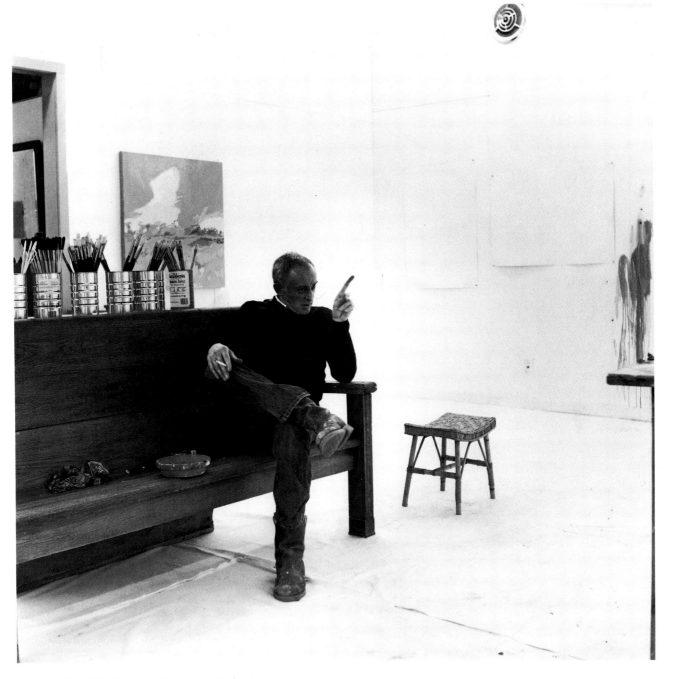

*ward surface of the fan,
and the flat plane of the
corner of the table is one
among the many other
subordinate triangular
shapes. A variety of
other subordinate
shapes allow the eye to
rest or pause.*

*The diagram shows
the use of open light,
which reduces the com-
position to shapes.*

*The picture is domi-
nated in area by light
shapes, and the dark
shapes are used in sub-
ordination. Here is
where an understand-
ing of an apparent con-
tradiction must take
place. Which is really
dominant? It doesn't
matter, for each comple-
ments the other. This is
why unity takes place.*

Control

in the

Studio:

Backgrounds

and Sets

Use the studio for what it is worth; it provides an open, neutral space over which you have total control. Instead of being limited to what the sitter's environment provides as a compositional element, you create a setting for the sitter. This setting can be a simple background of seamless paper, or it can be a constructed environment.

A simple background of seamless white paper can give an open look to the composition, while a black background will enclose, isolate, and hide the sitter. The corresponding lighting can be open and broad, enforcing the impression of honesty and good values, or it can be one-sided and narrow, showing only part of the subject and bringing into play a dark, hidden side.

A background can also include its own design elements. You can use a painted or a fabric backdrop, for example. A well thought-out background, however, should enhance the portrait and not be a separate or overwhelming entity. The background can add insight into who the sitter may be, or it can be neutral in that regard, but it should always be part of the total composition.

A more complex use of the studio is to incorporate sets into the photograph. This is one of the most important reasons to use a studio. Sets can range from simple flats to full-scale constructions and can be used as an abstract design or to duplicate a room or even a farm. More visually elaborate sets are used in advertising, where the budget can sustain the cost of such a production. With portraits, sets are usually simple constructions—perhaps just a wall and a platform, or a platform draped with fabric.

The idea of a set is to add something to your concept that two-dimensional seamless or fabric backdrops lack. A set creates a three-dimensional aspect. Again, the set must be incorporated into your overall concept and not detract from it by becoming overwhelming. It is key to remember that the sitter is still the most important product and the set is subordinate. We should never become enthralled with our handywork as carpenters. The set is just another tool of the studio, as are the lights, camera, and film; all perform a function, a means to an end. The end result is the portrait of a person, and not a reflection of your wonderful set.

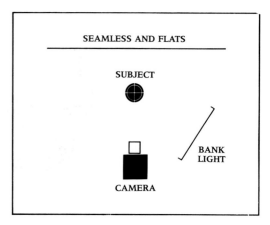

ROBERT
HENRY

SEAMLESS AND FLATS

SUBJECT

BANK
LIGHT

CAMERA

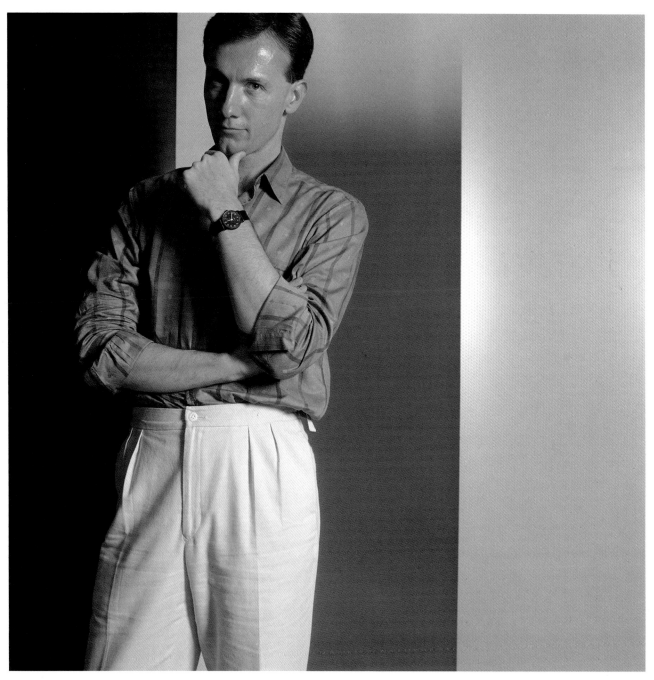

In this photograph, I utilized two flats and a white seamless. I wanted to achieve a spatial yet graphic look to be compatible with the sitter, Robert Henry, since he is a designer of exhibition space. By controlling the background and lighting, I found I could define both the sitter and the space he occupied.

Placing Robert between the two flats and letting him become a part of the created environment adds to the spatial concept. The lighting, a single bank light from the sitter's left side, highlights the sitter and allows his rounded form to come out, while forcing the flats to stay "flat." The light further enhances the set by creating cast shadows that also help the concept of space to be formed.

The resulting photograph of Robert Henry is a spatial concept which translates his vocation. The set was used to enhance the concept of the photograph, not to overpower it.

This photograph is an overview to show Robert with the sets as they appear before the camera crops into the desired space.

Because I wanted to make a statement about space, I staggered the placement of the flats. The gray, textured flat (a 4-foot by 10-foot sheet of Formica) is in the forefront. Next in line is the black flat (a 4-foot by 8-foot sheet of Formica). Finally, a white seamless is far back to catch shadows.

This Polaroid shows the intended utilization of the flats to create the wanted environment.

CARY
ZIMMERMAN

In this studio photograph of Cary Zimmerman, a designer of tennis racquets, I tried to pull together his designs along with his sensitivity for design. I chose to include his creations on top of a dark, modern sheet of Formica, which was a background that complemented his work. Cary was incorporated into the background by placing him on the same plane as his racquets. To give the products a high degree of visibility, I used a bank light from above as my only illumination.

With Cary lying down directly on the background and involved with his creations, I asked him to give me a Michelangelo-type pose, using his head and arm in a way reminiscent of the Creation of Man *in the Sistine Chapel.*

The final photograph incorporates a background which is of and about the subject, design. Even the way the racquets are laid out enhances the composition. Nothing is overwhelming, and we know what the photograph is about.

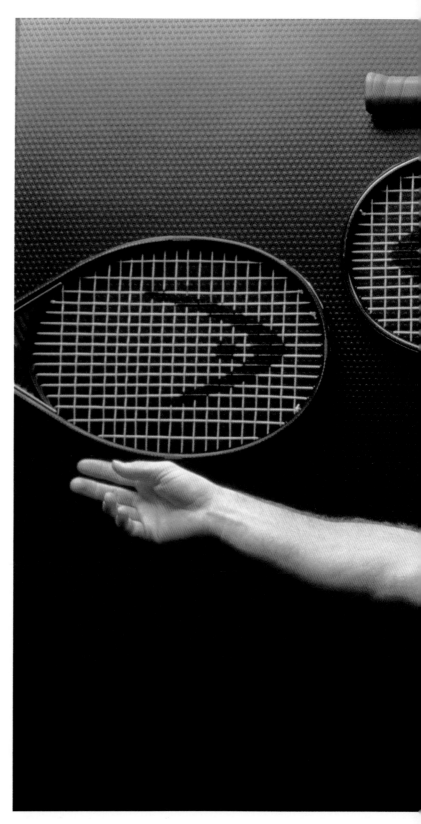

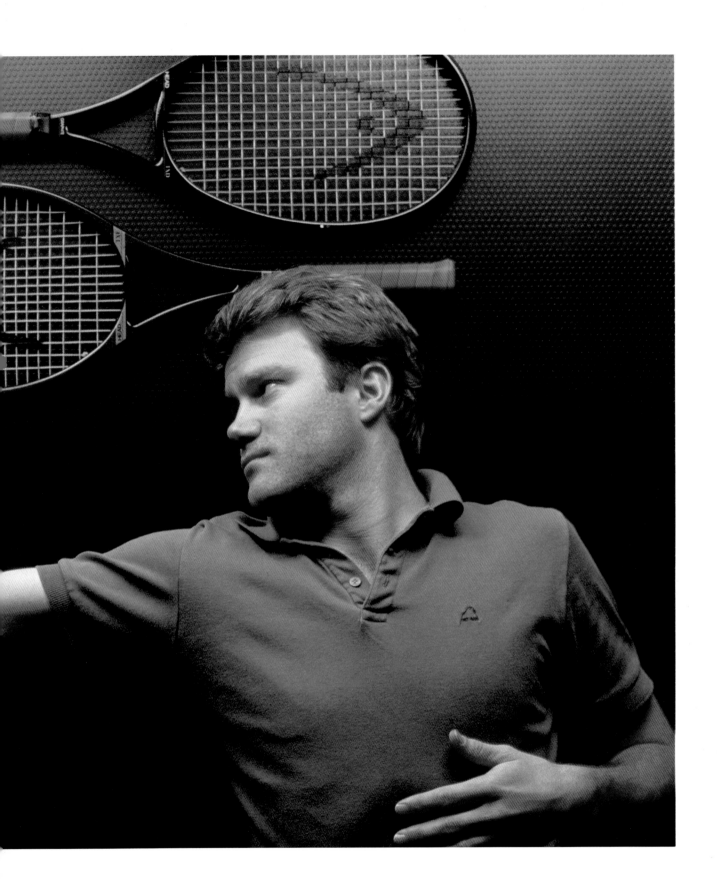

Control on

Location

Occasionally, you must photograph people at their convenience on location, even though the concept of the shot may call for a studio. In these cases, you have no alternative other than to load up the mule and bring your studio to the sitter. This may mean bringing backdrops as well as lighting equipment. Therefore, it is essential to think out and sketch your concept before leaving the studio; then make a checklist of all the supplies and equipment you will need to complete your shot. By doing this, you might be able to find solutions to problems usually solved by the use of heavy equipment. The underlying idea is to know your concept ahead of time so you do not bring unneeded equipment. What you must bring is what will be necessary to execute your concept.

When the concept calls for an environmental portrait, your choice of background and props is confined to what you find already existing in the situation. However, if you have done your research well enough, you will know what to expect before you arrive for the photo session. A preliminary visit to the sitter's home or office will give you specific details of the environment. But even if you have never seen the actual environment, your research should tell you in a general way what it is apt to look like. In either case, it is up to you to use your artistic vision and select the best background, props, and camera angle for the situation.

MARK
LACKO

When I visited Mark Lacko, I noticed his collection of antique tools and immediately thought this to be a wonderful background, especially in contrast to the fact that he is a modern, hi-tech designer. Sketching out a concept, I was set. It is that simple to execute the concept when you know your skills.

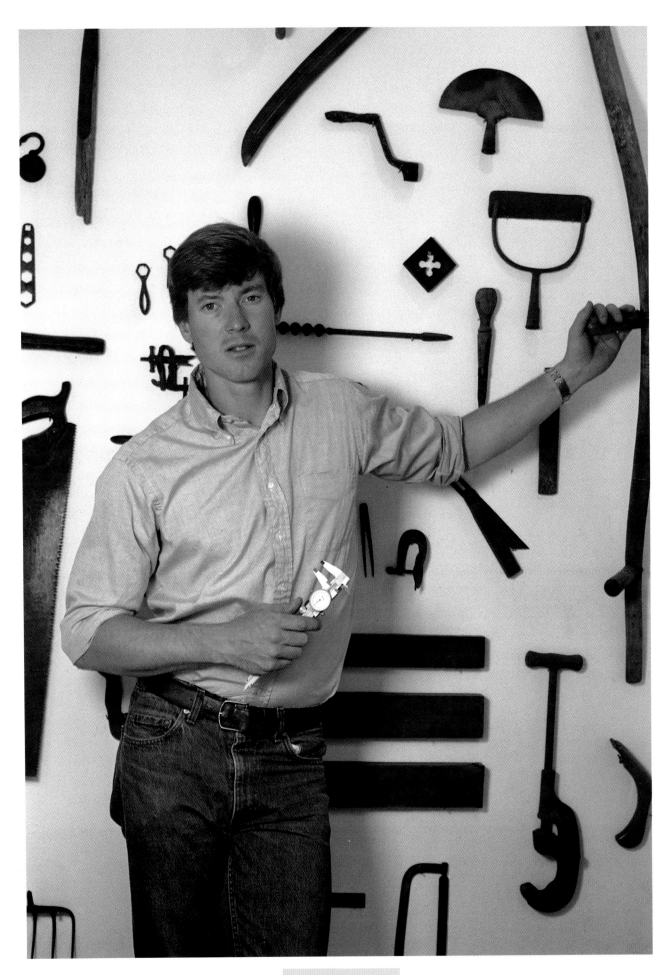

ARTHUR ASHE

An advertising poster featuring tennis star Arthur Ashe was contracted to be shot while he was doing some promotional work at a tennis match. The location of the match and Arthur's schedule made it impossible to set up an appointment at the studio, so instead, I brought the studio to Arthur.

The concept that the art director and I had agreed on was to place Arthur in front of a row of international flags to show his connection with the Davis Cup competition. The director and I arrived at the location early and put up heavy stands with a line between them. Then we clamped, in specific design order, the flags of our choice. We set up our lighting, incorporating the natural light as fill light and as backlight to filter through the flags. The outdoor setup is shown in the photo below.

The preplanned concept led to a checklist, which led to the improvised use of natural light. As a result, we were able to travel lightly and efficiently and then set up and shoot effectively and professionally. Nothing was sacrificed by shooting with a studio atmosphere on location.

After completing the assigned shot (see pages 58–59), I photographed Arthur without his tennis racquet, stressing the strength of his own emphatic personality (photo at right).

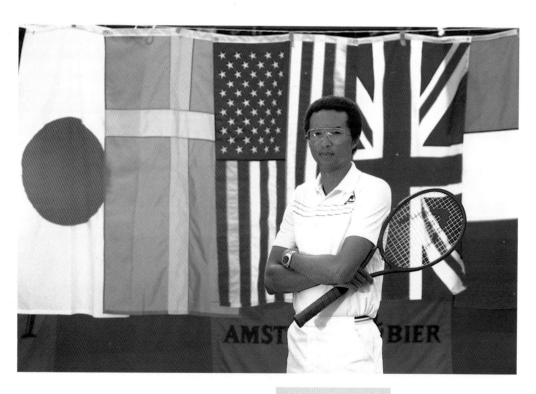

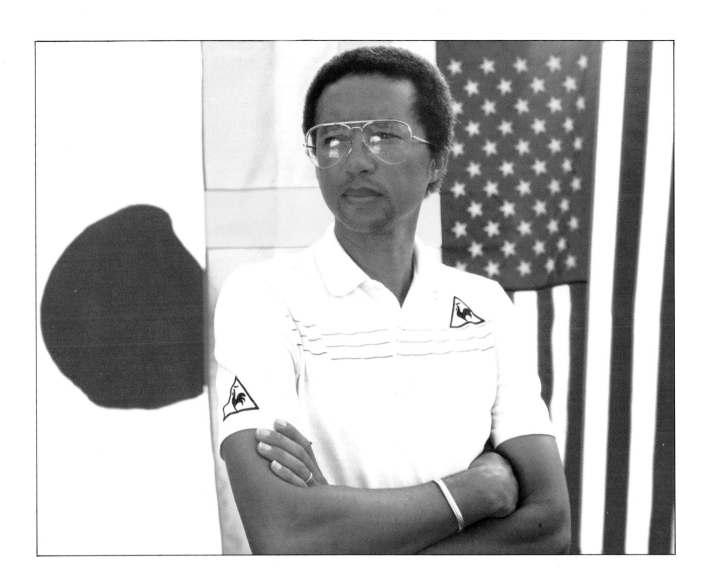

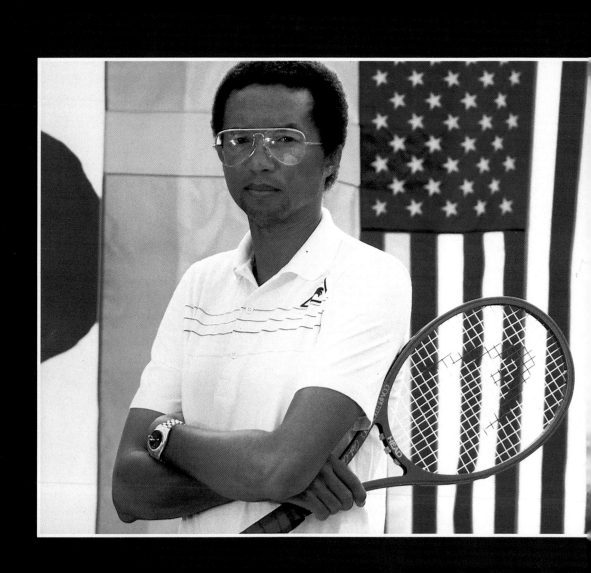

For the final version of the poster, we selected a shot that provided a balance between the featured equipment (a Head tennis racquet) and the endorsing celebrity.

TED
LEWIN

ENVIRONMENT

SUBJECT

BANK
LIGHT

CAMERA

Ted Lewin is an artist whose work has appeared in many books. He has also been very influenced by boxers and wrestlers. As a result, many of Ted's own paintings have themes oriented towards boxing and wrestling.

I chose to show Ted in his studio, offering the viewer his forceful signature. A dark background, which allowed enough light to show his work, emphasized Ted's forcefulness. This photograph, I believe, is ultimately aided by my inclusion, for design purposes, of the white light fixtures and the diagonal of the ladder.

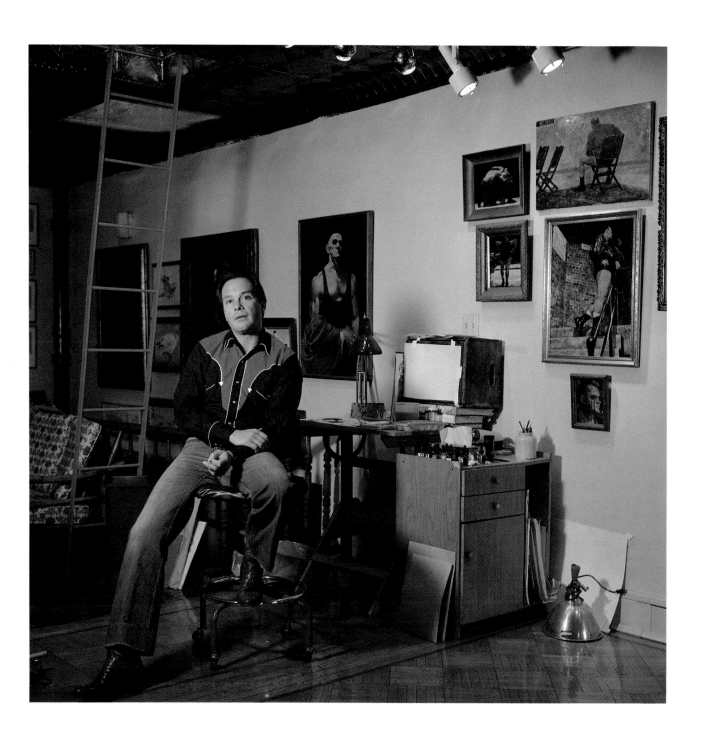

BETSY LEWIN

ENVIRONMENT

SUBJECT

CAMERA

BANK LIGHT

When I photographed Betsy Lewin, I used a different part of the studio she shares with Ted. I shot her with and without her cat, who would intermittently sit on her lap and then leave. Betsy is an illustrator of children's books and I wanted to catch her with a simple "schoolgirl" look. The environment helps convey that she is warm and trusting.

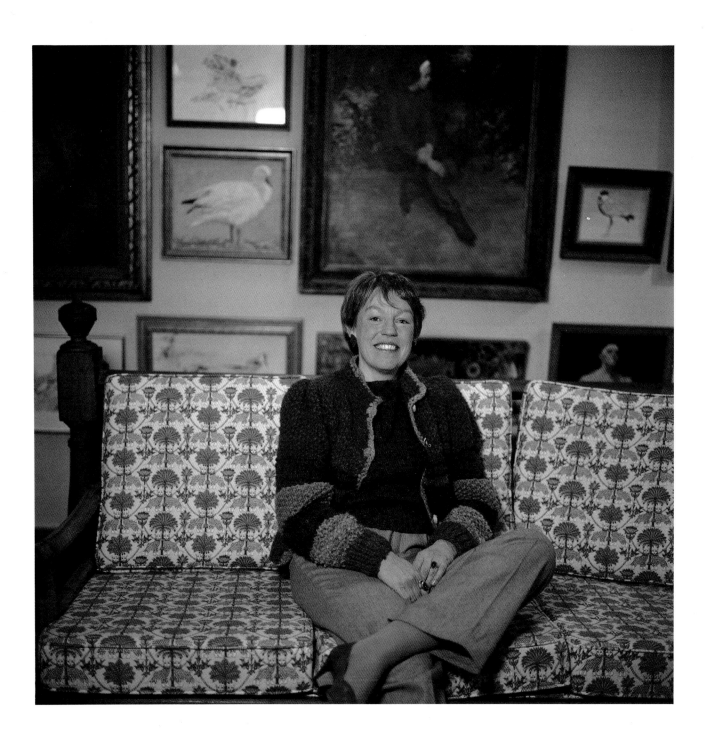

4

Here, the open quality of the lighting helps reveal the friendly, casual, bright, and breezy nature of the sitter, musician Steven Calicchio. Both Steven and the background are clearly described by the lighting.

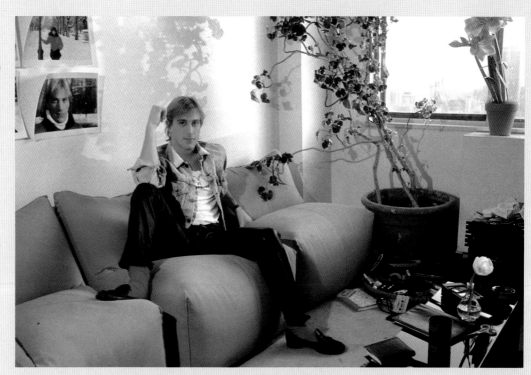

LIGHTING

TECHNIQUES

Without light you cannot photograph. To photograph is to draw with light. Varying degrees of light create shade and tone and ultimately the photographic image. With darkness, there isn't any image; it is the light cascading over forms and creating highlights and shadows that produces the photographic image. Without light, you would have the proverbial bear-in-a-cave photograph. With light and its varying degrees of intensity, you can create anything.

Manipulation of light is often the difference between the success or failure of a work of art. There must not be too little or too much light, and there must be the right kind of light—whether soft and diffuse or strong and direct. The artist—whether a painter or photographer—must have an understanding of the interpretive power of light.

Many artists have spent their entire lives creating works based on the use of light. Examine the paintings of Rembrandt, Vermeer, Monet, and Van Gogh. Look at the photographs of Emerson, Stieglitz, Weston, and Adams. What all these artists have in common is that their work is never compromised by bad lighting. In fact, it is usually their lighting that makes their work stand out from other artists. By comprehending the characteristics of light—what color it is, how bright it is, the shadows it casts, and the relationships it creates—the photographer begins to understand the differences light offers.

Qualities
of Light

One factor to recognize is that the quality of daylight varies according to the time of day and atmospheric conditions. On a clear day, the light shortly after sunrise or shortly before sunset is warm (orange or red in color) and slightly subdued in intensity. At noon, when the sun is directly overhead, the light is whiter and more intense, even harsh, and it is apt to throw heavy shadows on the subject. The presence of haze or clouds alters the nature of light by scattering or reflecting the direct rays and opening up the shadows. Truly overcast days offer extremely even, diffuse, and shadowless light with a slightly bluish cast.

Artificial light approximates the same qualities as natural light. It can be soft and diffuse or harsh and direct. It can be cool (bluish) or warm (reddish). It can be flat, open, and shadowless; or it can be sharp, narrow, and heavily shadowed.

The light, whether artificial or natural, has to work with the subject, and the by-product shadows and shade have to enhance, not overwhelm, the concept. The creation of a particular quality of light can be an elusive task.

BIBI
PHILLIPS

For an article in Hamptons Magazine, I photographed BiBi Phillips outside her shop in East Hampton, New York. I wanted to get up high to have an overview of BiBi and her patio, which serves to relax her customers as they shop at ease. The intense sunlight resulted in strong contrasts and mirrored the quality of a bright summer day.

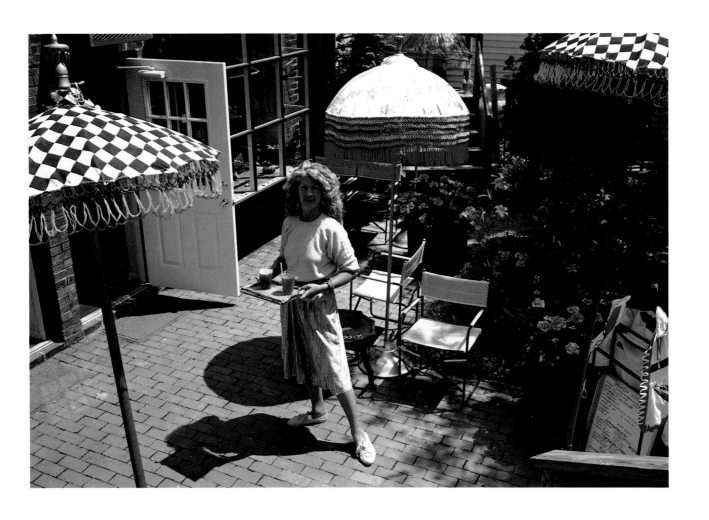

Open

Lighting

Open lighting is a technique that virtually eliminates shadows. While this can be obtained by using a single light source, the setup usually incorporates more than one light. Normally this would consist of a broad main light, filled by two additional light sources (umbrellas, reflector cards, or bank lights) placed on each side of the subject.

With lighting of this type, the overriding look is clean, crisp, and graphic. The light describes line and doesn't allow perspective to be defined. Open light is even and diffuse, like that from an overcast day; it flattens out the subject. Shape is what is defined, and therefore the sitter's placement must be determined by design reasons.

With open lighting, the photograph can become a two-dimensional graphic statement that relies almost entirely on composition for its message. The lighting fully describes both the subject and the background. The photographer, through placement and posing, leads the viewer to the main ingredient of the photograph. The whole photograph is open to the viewer's inspection and scrutiny.

MICHAEL
GRIMALDI

Open lighting relies on composition and framing to do its bidding because it suggests shape rather than three-dimensional form. With the right placement of objects, the composition will work properly. This photograph of Michael Grimaldi was done using three bank lights arranged in front of the sitter to envelop him in light. Michael, a photographer who shoots landscapes, is pictured with two of the most important components of his work. The camera and a portion of a landscape flank the sitter and make him the central component of the photograph.

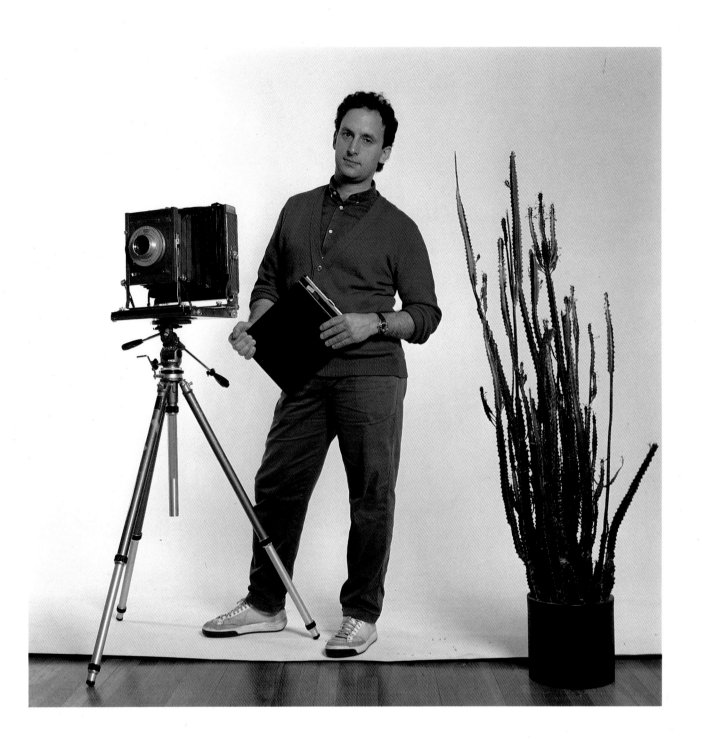

KEN SOFER

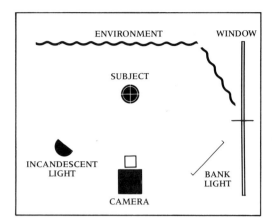

Ken Sofer is a painter and writer. I photographed Ken in his studio and wanted his work to be the backdrop. I tried to use as much open light as possible to show Ken as well as his work. Natural light from a window to Ken's left was incorporated with strobe light bounced off the ceiling to his right.

PAM
LEVINE

WINDOW

SUBJECT

CAMERA BANK
LIGHT

Pam Levine is an independent jewelry designer who works countless hours in her studio. I wanted to shoot Pam in her studio in a relaxed pose. I asked Pam if, when we shot, she could sit in her studio and be pensive yet relaxed. I used the natural light from the windows behind the sitter, as well as a bank light from the front, to obtain an "open" look and describe the environment fully.

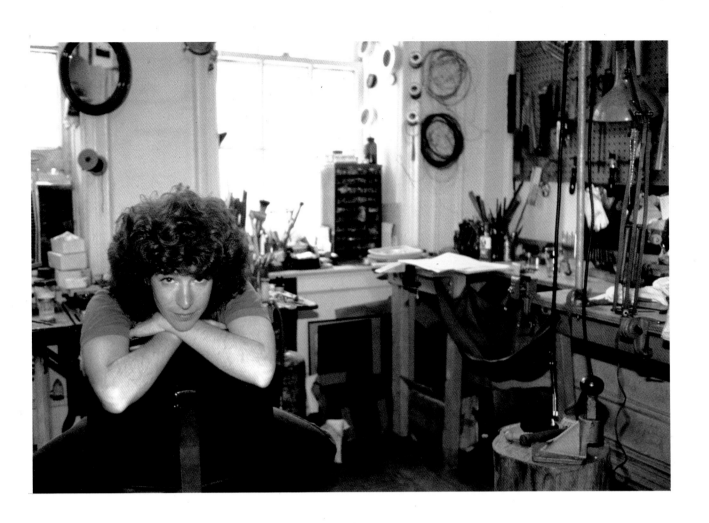

Sidelighting

A single light can be placed to create illumination on one side of the subject while casting the other side into shadow and darkness. The influence of placing the light on the side is that of hide-and-seek. The lighted side of the sitter can be translated as the shown side, or the known part of the sitter. The dark side of the sitter represents the unknown or hidden side.

With sidelighting I usually use a black card on the side opposite the light to deepen the black and increase the contrast; if I use a white card, that side opens up and becomes less dramatic. The power of contrast is what begins to come forward—dark and light, white and black.

The strongest effect is produced when the light is placed at an extreme angle to the camera-subject line, say 90 degrees. The viewer is more accustomed to seeing the subject lit from the side at a 45-degree angle or from a full frontal view. When the lighting is more extreme, the viewer's response to the portrait becomes extreme. The photograph takes on a powerful, hard look, and the image elicits an immediate response—either of enjoyment or of disdain. There doesn't seem to be any middle ground when using light of this extreme; instead, the heightened contrast provokes either a positive response or a negative one.

The dark and the light allow viewers to consider both the openness and the secretiveness of the sitter, the good and the evil. We give viewers an insight into the sitter; then we cut it off and allow them to decipher the rest. It is the difference between a radio drama and a television drama. The imagined is more powerful and penetrating than the given.

For this photograph of movie producer Reid Shane, I decided to use a sidelight to create heavy shadow and light. I placed Reid in the studio with some tools of his trade about him. This, along with the clapboard, lets the viewer know who and what Reid is. The photograph is designed to give the viewer some vital information about Reid and not much more. It is then up to the viewer to imagine the rest, based upon the subject's presence.

The light adds to the depth and mystery of the photograph; it allows the viewer to become an integral part of the photograph, to become involved in the portrait not just as the viewer but as the interpreter.

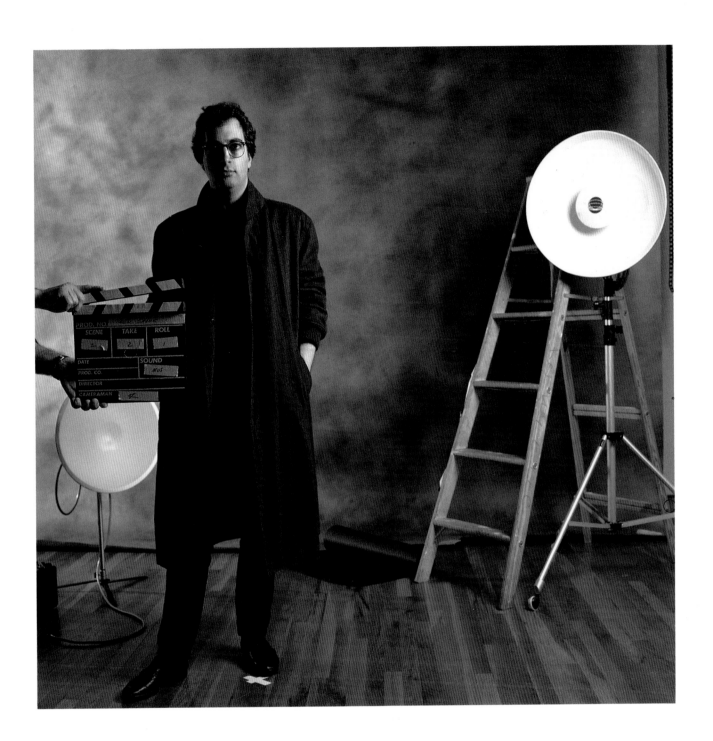

Spotlighting

Spotlighting is a powerful lighting which also has extremes—extreme brightness and extreme shadow. The power of the light is its tunnel-vision effect. It seems to be light through a pinhole or keyhole, describing only part and keeping all else in the dark. Spotlighting is used to pinpoint one area and give that all the importance, letting all else fall into mystery.

The use of spotlighting will emphasize a single-dimension concept, that is, a concept with no extra influences to alter it. The light is direct and forthright.

STANFORD SMILOW

Stanford Smilow is a commercial photographer whose roots as an artist are in the 1960s. I chose spotlighting because it seemed reminiscent of that era and because it would emphasize the forcefulness of the sitter's character. The light pulls part of Stanford out of darkness, out of some hidden area; it focuses in on his pose and expression and leaves all the rest in uncertainty. Stanford's penetrating look, folded arms, and blue shirt further the notion of boldness and mystery. We know that the sitter is bold and forceful, but nothing else is told.

The single light source was placed at a 45-degree angle to the sitter's right side, with one black reflector on the opposite side to enhance the deep shadow.

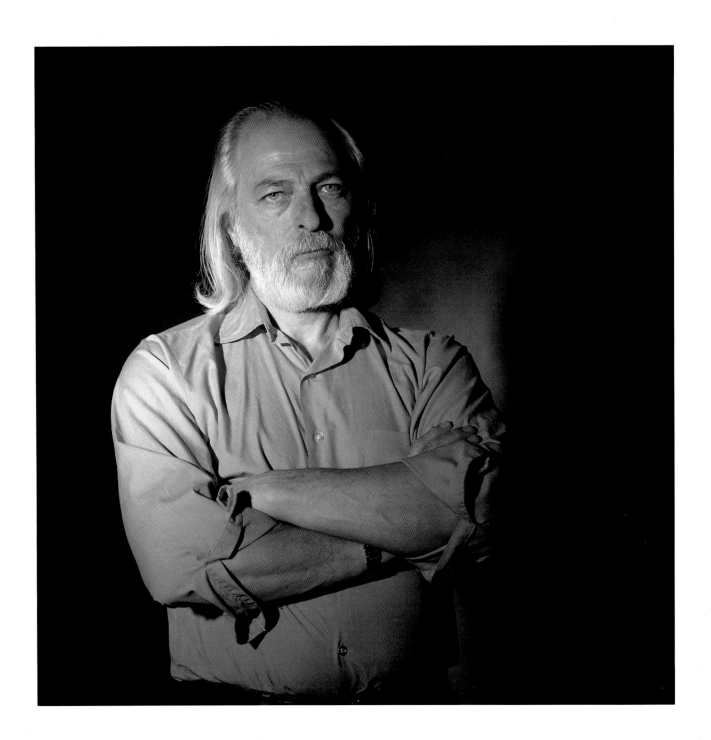

Tenebrism

Tenebrism is what most laymen might refer to as a Rembrandt lighting technique. Tenebrism relies on an interplay between lights and darks. The subject is illuminated by one light source placed directly in front of the subject, but in close proximity so that the fall-off of light is extreme and the background remains dark. The overriding influence is the darkness.

Imagine a dark room with a blaze in the fireplace and someone sitting near the fire. There are no other lights. Looking at the subject, you would see warm highlights and surrounding darkness.

The power of the darkness allows the photograph to become a study of lightness. It is through the interplay of the dark and light that you separate the sitter from the background.

The highlights and light areas are not necessarily as bright as they might appear. The contrast between the dark and the light is what makes the lights appear so much lighter. To light in this manner, I use a bank light, which is a directional but diffused light. When you use tenebrism, it is usually important to use only one light, as this enhances the directional quality. With more than one light, you begin to flatten out the subject and lose the contrast between the light and dark areas.

ROSALBA
DEL VECCHIO

Rosalba Del Vecchio, a literary figure who loves the visual arts, reflected a sensibility that reminded me of Early Renaissance portrait paintings. Between her environment and her physical traits, I saw her as the Italian patron who would be painted as the Madonna. For these reasons, I felt that the lighting qualities of the bank light most enhanced the character of my sitter and the visual statement I wanted to make.

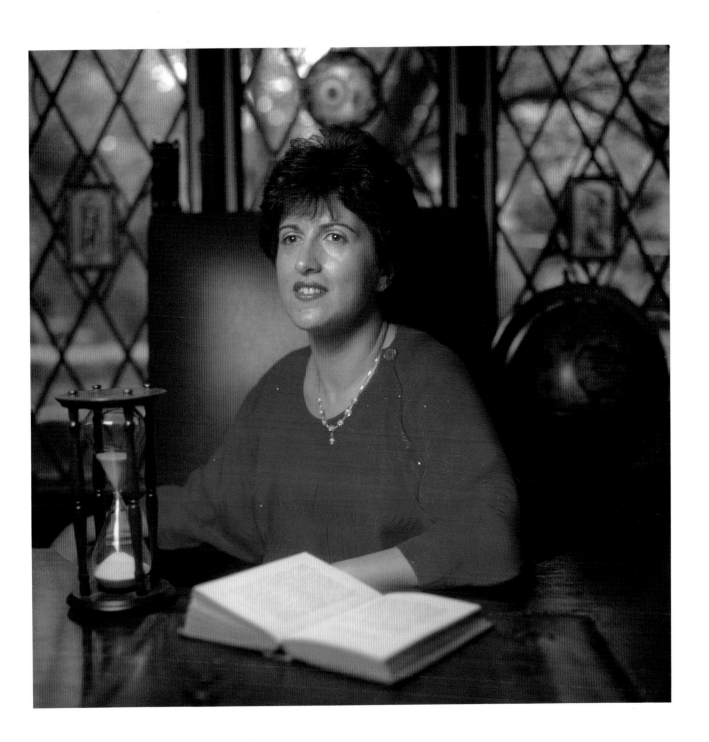

Window

Lighting

The effect of window lighting lies somewhere between open light and tenebrism. As the name implies, this is a technique meant to imitate the look of light coming through a window and hitting the full face of the subject. There is some fall-off behind the face, but the light-to-dark relationship is more subtle than that of tenebrism.

Window lighting is influenced by tenebrism, but because the light source is farther away from the subject, the lighting is softer and broader, thus opening up the surrounding areas. There is usually one light source but not always. When I artificially light in this mode, I use reflector cards to further open up the shadow area, or on occasion, I use lower-power lighting as fill-in. The overall effect should still look as if there is only one light source.

Window light's power is its ability to illuminate the sitter with enough reflective power to subtly introduce the nuances of the environment. With the window light, you are able to thrust your subject to the forefront. With the nuances slightly lit, the viewer can interpret who the sitter is.

TONY DEL VECCHIO

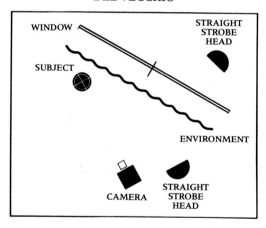

With Tony Del Vecchio, I decided a window light would add to his Old World charm. In the photograph, I literally used window light by placing my main light outside the window to the sitter's left. I placed a straight reflector at a small distance away from the window so that the window would diffuse the light. I added a small fill-in light at slightly three-quarters frontal to open up the shadow area.

The resulting photograph has a slight air of mystery, possibly similar to the mystery involved in a minor language barrier.

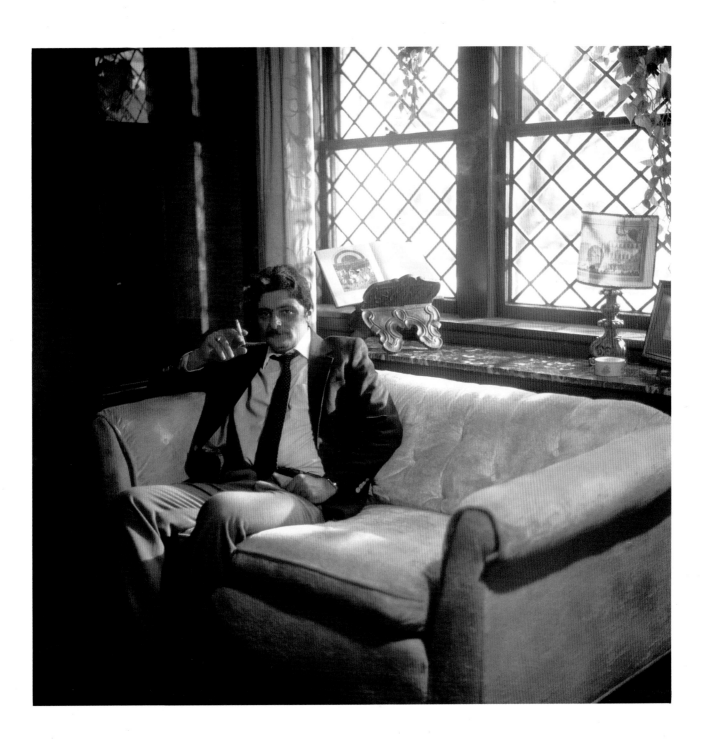

5

An effective portrait includes pertinent information about the sitter. In this instance, I used photographer Richard Rodamer's own studio and lighting to catch Richard as he was about to shoot an assignment of his own.

TELLING

THE STORY

The effective portrait will tell a story about the sitter. The environment, the clothing and props, the pose and expression, the lighting and framing all contribute to that story. To be effective, however, all the facts have to be true. False facts around the sitter will contradict the sitter's presence and make the portrait disjointed and unintelligible.

When the viewer looks at the photograph of the sitter, it should be a realistic depiction of the sitter and not the photographer's biased opinion. Showing as much information as possible makes the viewer's job easier. If you are truly honest and observant, however, you can photograph more abstractly and still convey who your sitter is. The eyes and hands are often the most telling parts of most people's personality and can be enough to illustrate the sitter.

The photographer tries to document, not alter, the facts. The viewer responds not only to the document but also to the emotional content of what the sitter wishes to present. The sitter may wish to be portrayed as a happy, smiling, upbeat person or as mean, melancholy, and somber. The photographer recognizes these offerings, usually one per sitter, and tries to put them into a frame of reference. An upbeat person would look incongruous in a melancholy environment. The photographer directs the visual elements that convey the thematic concept, and these elements allow the viewer to decipher the sitter. The emotional content of what the sitter conveys influences the viewer's response to the portrait.

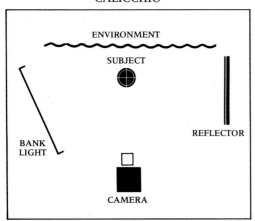

TOM
CALICCHIO

ENVIRONMENT

SUBJECT

REFLECTOR

BANK
LIGHT

CAMERA

Although Tom Calicchio is a lawyer for an international concern, his main passion is the automobile; he is both a collector and a racer. Collecting and racing suit him equally well, although the racing does bring out his competitive nature.

I chose to photograph Tom in his racing suit and in the studio, where I placed Tom in an easy chair to set him at ease. I still felt I needed a prop, to help compositionally and to push Tom's racing involvement to the extreme; for this reason, I included the model racer in the lower-left corner of the photograph.

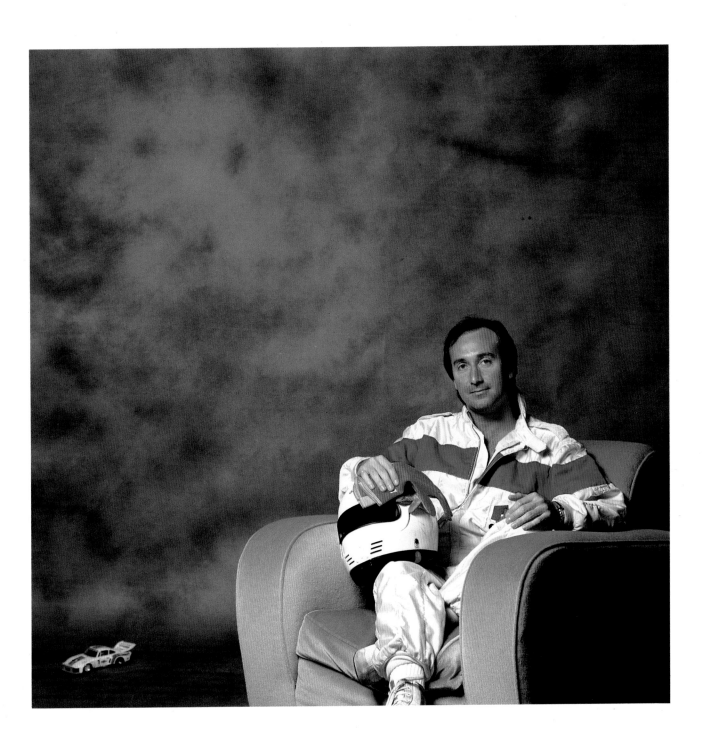

BRYANT
GUMBEL

ENVIRONMENT

SUBJECT

STRAIGHT
LIGHT

BANK
LIGHT

CAMERA

The portrait of Bryant Gumbel, host of NBC's Today *show, was done as part of my personal project to shoot New York newspeople. I had written to him, and he had agreed to be photographed.*

Before we began the photo session, I ex-plained that the shot was to be environmen-tal, that I wanted to give the viewer as much information about him as possible. In response, Mr. Gumbel asked to have his toy-bear collec-tion included, so we placed some of his "pals" in close prox-imity to him. The total environment shows the eclectic nature of the sit-ter. The room is neat but filled. The pictures and objects that sur-round him reflect his love for children as well as his interest in sports and give insight into a public personality.

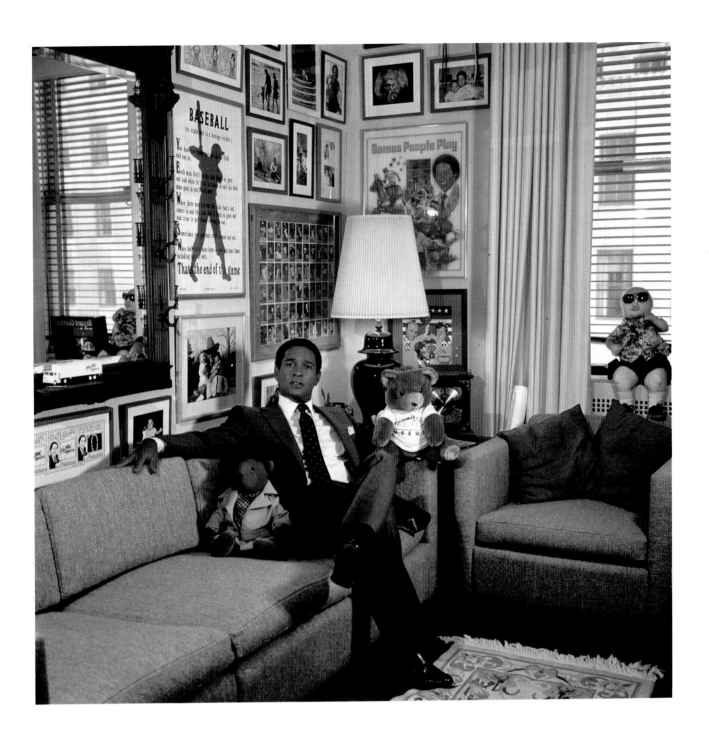

The photograph of theater and movie critic Pia Lindstrom shows the sitter with a clipboard and a video cassette. The props indicate to the viewer that the sitter is involved with movies and writing, a critic. The broad lighting flatters the sitter and opens up the entire photograph to the viewer's examination. The pose and expression capture the sitter's natural presence and her wry sense of humor.

Although the head shot of Pia allows the viewer to recognize the sitter through facial characteristics, it does not necessarily inform the viewer further. The inclusion of props can add to the interpretation.

OSCAR SHAFTEL

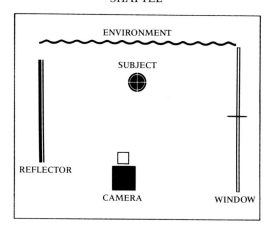

I photographed Professor Oscar Shaftel after one of his classes on Chinese literature. I allowed natural light from a window to filter in from behind and illuminate most of the image. Reflector cards were used in front of the sitter to fill in the shadow. Allowing the chalkboard to go out of focus created an abstract symbolism from the literary environment and made the sitter the most important aspect of the picture.

Professor Shaftel took a pose and chose to hold two books. At first, I thought this to be wrong, since who would hold two books? Besides, wasn't one symbol enough? As I stood by the camera, it began to make sense. The sitter has some right in deciding what he wants a viewer to interpret. Secondly, the two books lent themselves to the intellectual capabilities of the sitter. He is not a one-dimensional person. He is an advanced, free thinking, learned man. The books did indicate something additional.

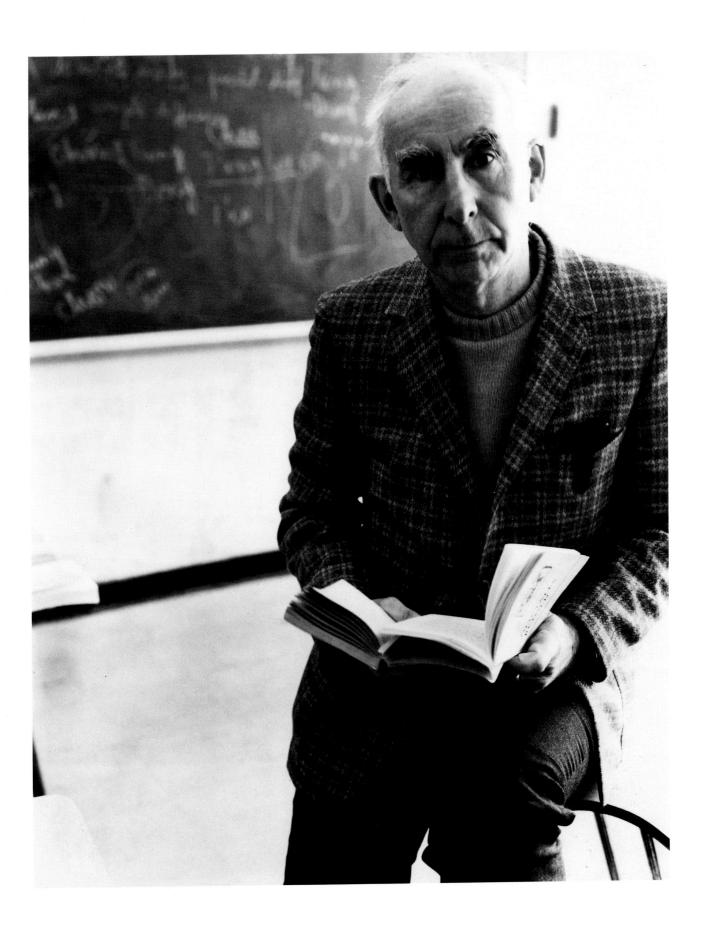

NORMAN MAILER

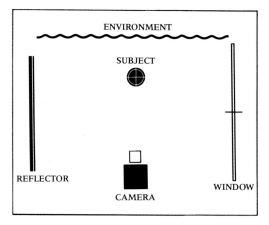

ENVIRONMENT

SUBJECT

REFLECTOR

WINDOW

CAMERA

Author Norman Mailer imposed strict demands on the shooting—twenty minutes, no flash, and he must be shot while in the process of being interviewed. Allowing his southern wall of windows to act as my bank lighting, I placed flat reflector cards opposite the window and used the room's lamps to fill in.

My immediate response to Mr. Mailer was that he reminded me of my own father—intelligent and creative, forceful and positive. With one ear, I listened to the conversation to have an idea of the emotions and expressions that might be served up. Throughout the twenty minutes, I never set the camera on a tripod. Walking around the sitter, I got a varied set of poses. Soon we were finished, and I was able to come away with a portrait that shows the quiet, thoughtful side of a literary great.

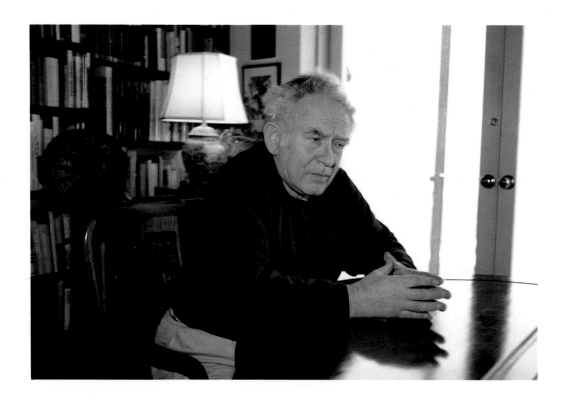

DAVE
MARASH

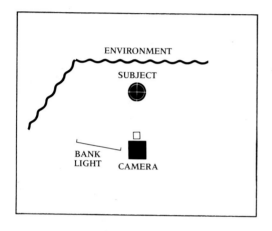

My portrait of TV reporter Dave Marash shows a consistency in the use of framing and lighting to translate information. Marash is an investigative reporter who digs deep into his stories; he is very thorough and professional, inquisitive and compassionate. I wanted to emphasize his relaxed, intelligent nature and still include nuances of his work environment. The straight-on view, the informal pose, the inclusion of background details, and the broad lighting all contribute to the final impression the viewer receives.

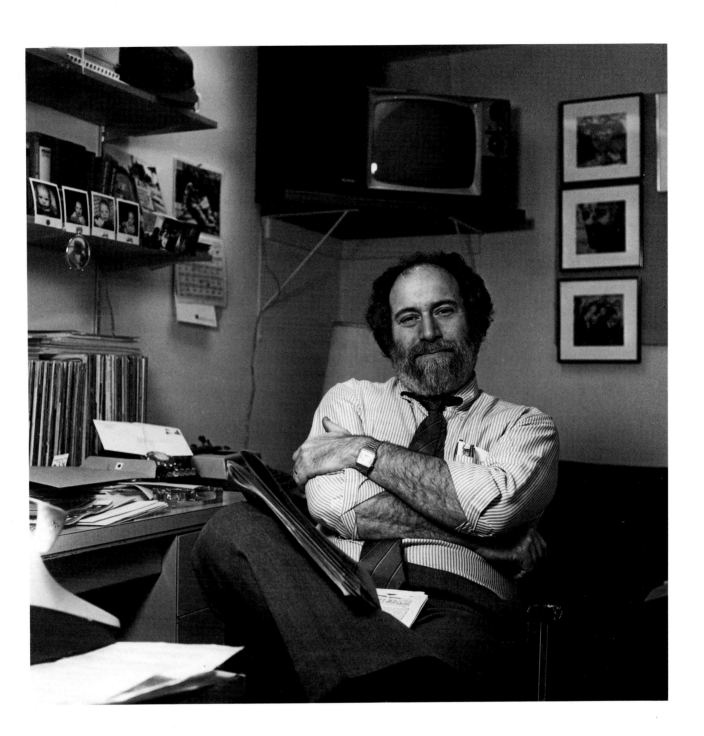

VINCENT COLABELLA

My father, Vincent Colabella, is an artist who for some time has been involved with religion as a scholarly endeavor. For years, his studio has been a hazard to anyone who entered unprepared. He accumulates various reading materials—books, magazines, articles; eventually he gets to them all so they do serve their purposes.

I attempted to make sense out of the confusion of his studio by showing him in the dual role of artist and scholar. To do this, I included one of my father's paintings, a painting of Christ teaching His followers; then I encouraged the teacher in my father to surface. To my surprise, the pose in the painting and my father's pose paralleled each other. I had achieved my goal, to show my father as an artist and thinker and to make sense out of an environment that, for most of my life, has been in organized disarray.

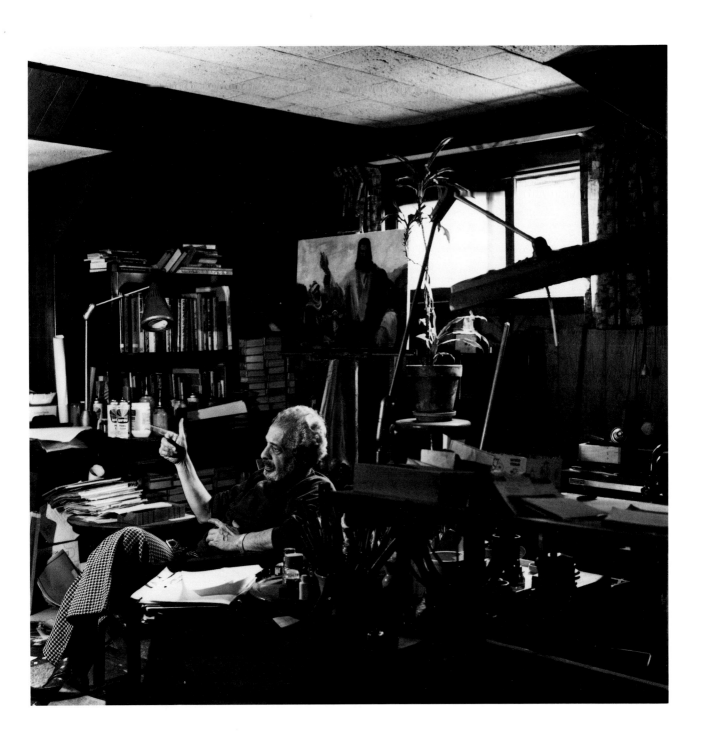

Here, I've chosen to photograph my father's hands because I felt I could show his tenderness as well as his profession. To enhance the tender aspect, I chose to light softly with a shadowless light from overhead. The inclusion of certain props allows the viewer to ascertain that these are the hands of an artist. More often than not, it is important to see the person's face and body, but there are those cases where the effective action is to show the person by other modes. Narrowing the focus to one feature can often convey the intangibles of intelligence, thought, and spirit.

An alternate photograph taken with hard light does not have the same easing effect of the softly lit photograph. The concept of the photograph was to show the tenderness of the hands. Soft lighting aids the concept; hard lighting detracts from it. Hard lighting is undiffused. Soft light is created by using a bank light or umbrella lighting.

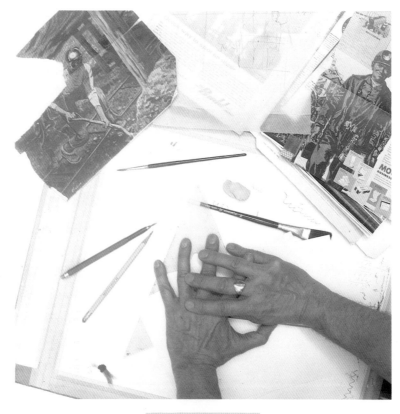

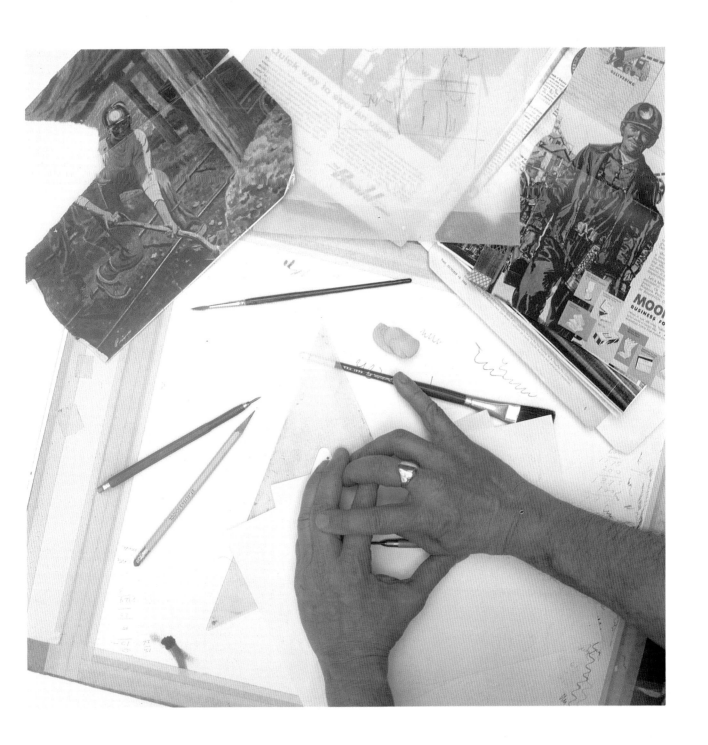

The viewer's response to a particular portrait correlates to the overriding emotionalism of that photograph. I took two portraits of entertainer Tommy Sykes. One was used for Tommy's album cover and represented the image he wanted to portray. The other was taken for my own files and represented a different Tommy.

For the album, Tommy wanted a "tough-guy" look. We chose dark clothing and a seedy environment to characterize toughness, and we photographed in black-and-white with an overcast sky to add to the somber feeling. The background of old factories under the Manhattan Bridge in Brooklyn provided a seedy environment at its best. Tommy reacted to it by continually using his body language and facial expressions to create a tough-guy image. The overall impression is successful in creating a somber mood. The parts— dark clothes, cigarette, seedy environment, dull light, black-and-white film, and the hobo in the background—all add up.

Additional photos, used on the album's back cover, show Tommy's consistent mood as he varied pose and expression in that particular environment.

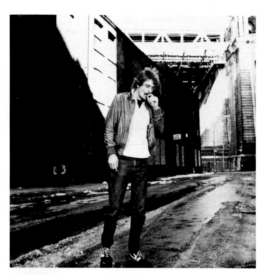

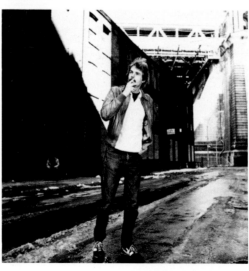

TOM SYKES

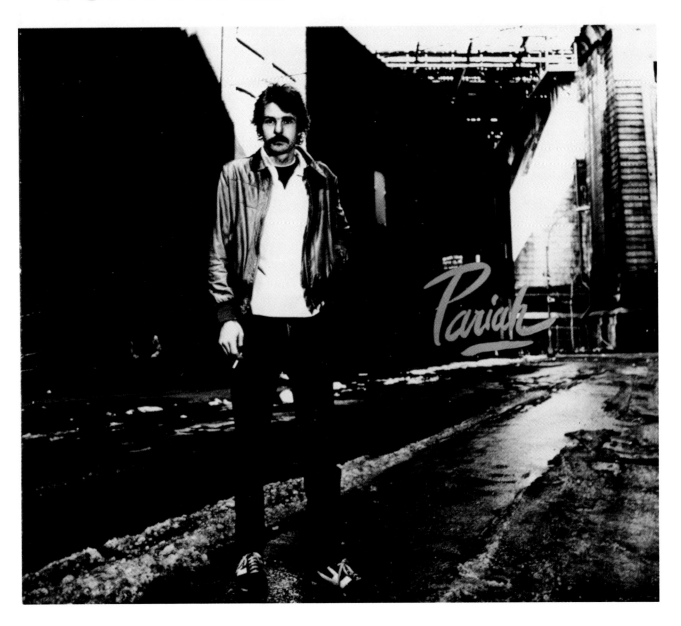

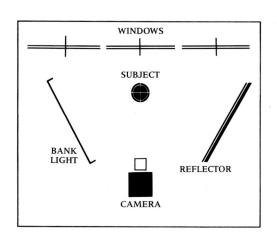

WINDOWS

SUBJECT

BANK
LIGHT

REFLECTOR

CAMERA

In contrast to the impression required by the album cover, my own evaluation of Tom was that he was a tender, caring, happy person. I chose to photograph him in color, with a light background and a lot of open, bright light—even including light spilling in from a window. Although he still wears the same clothing as he did for the album cover, he is now relaxed and smiling. All of these elements add up to an upbeat, positive look at Tom.

The viewer is bound to have a different emotional response to each of these portraits. As the sitter's pose and expression vary in response to the situation, so does the psychological response of the viewer.

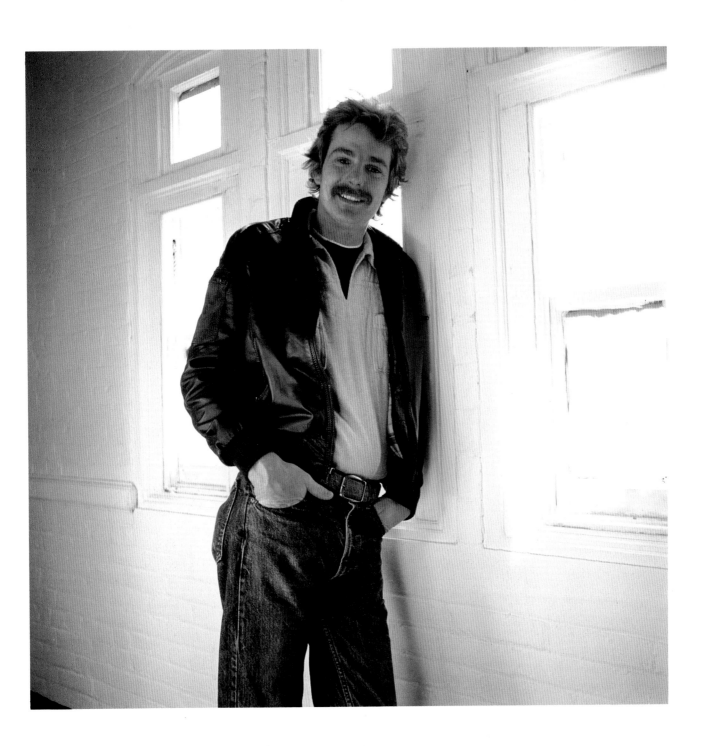

GENE MAYER

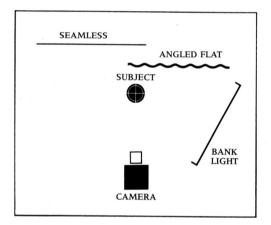

SEAMLESS

ANGLED FLAT

SUBJECT

BANK LIGHT

CAMERA

In the portrait of Gene Mayer, I wanted to emphasize the fact that he is a designer. To this end, I decided a graphic look would be best. The visual statement I wanted to make with the concept of graphics was the power of the diagonal. To start, I positioned two flats— one gray and one black—to form a background of gray and black triangular shapes. I placed the subject so that his right shoulder, elbow, and hand form one triangle, while his left shoulder and arm form another. I placed the main light overhead, at a 45-degree angle to the side, to cascade light over his face in yet another diagonal trend. Lighting from the left side of his head resulted in the opposite side falling into a slight shadow.

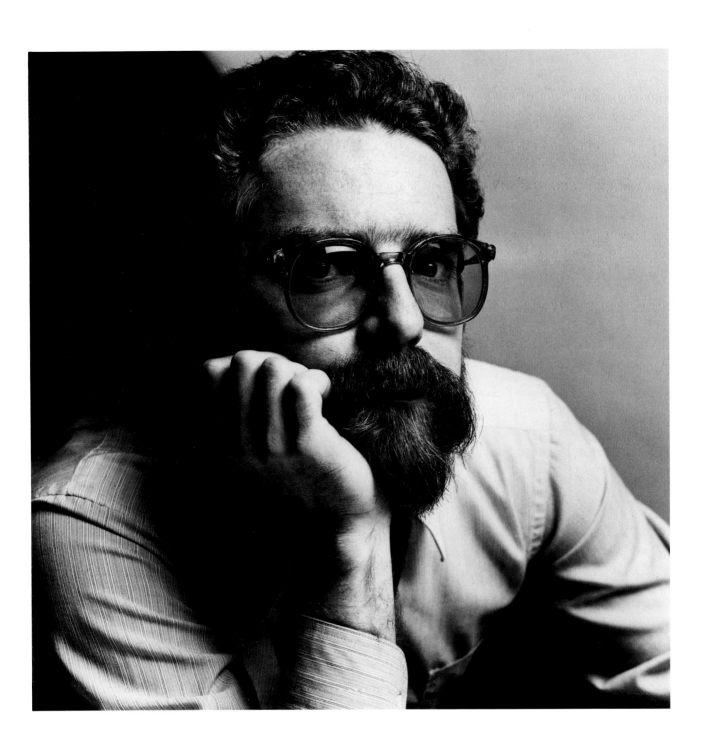

SHARON KERR

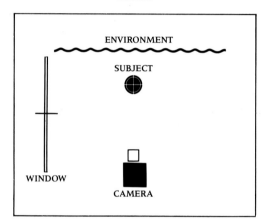

ENVIRONMENT

SUBJECT

WINDOW

CAMERA

Art curator Sharon Kerr sat for me in her gallery a short time before a show of my work was to be hung. Wanting to express her creativity, I chose to photograph Sharon by including the three-dimensional works and paintings that were currently being shown. Sharon's personality is strong and open. She is completely at ease among the artwork, as if she were in her own living room. She is as willing to share her knowledge about art as she is to show the works for others to enjoy.

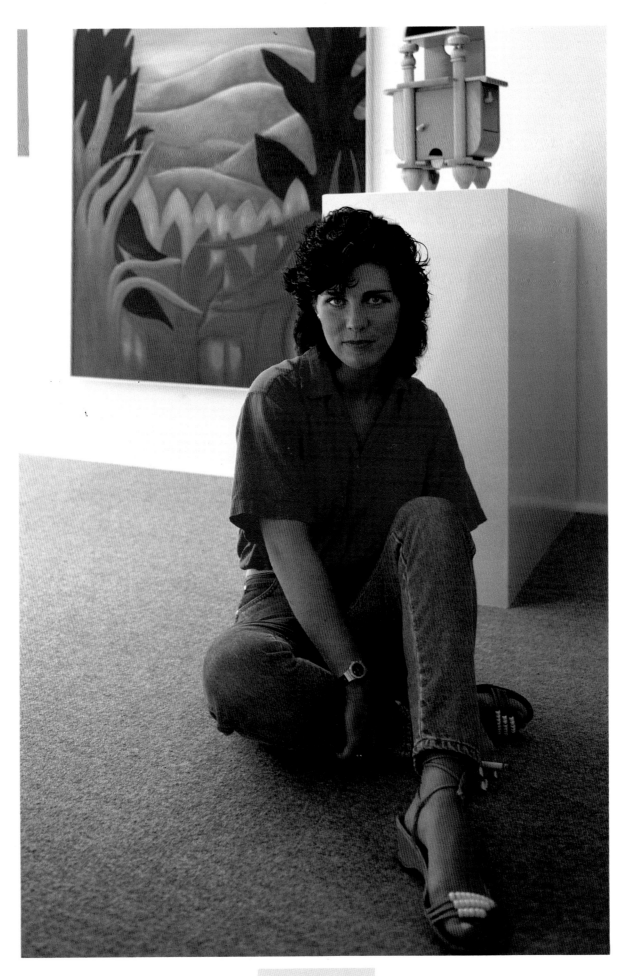

6

A professional mime, such as Rita Nacht-mann, is an expressive personality who tries to tell a story with gestures, expressions, and a few minor props. A full-length portrait reflecting her acting abilities might be included in a photographic portfolio submitted to prospective employers. This particular photograph was taken after Rita and I had completed an assignment for Warner Communications.

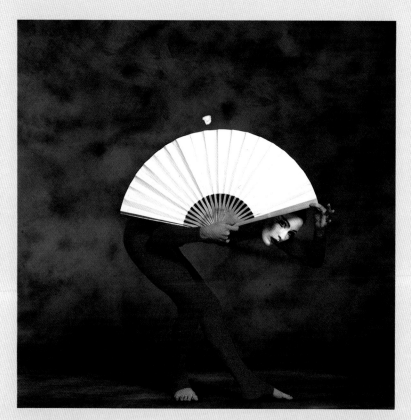

SPECIAL KINDS OF PORTRAITS

While an effective portrait will, as its primary purpose, display at least some aspect of the subject's personality, there are some areas of professional portraiture that involve additional considerations. One consideration might be the ultimate use for which the portrait is intended; another consideration might be the specific techniques that are required to display particular subjects to their best advantage.

When a portrait is used for an advertising campaign, the subject usually serves as the personification of the concept that the advertisers want to present to the public. Many times, this concept may be very far from a true reflection of the model's real-life persona. But this does not mean that the subject should be presented as a lifeless mannequin—some sparkle and personality has to come through, or the resulting photograph will hold little interest for the viewer. The photographer's aim in such cases is to achieve a balance between the client's needs and the model's ability to project a specific image.

At other times, you will find yourself photographing more than one person and your portrait is actually of a group. These situations can be as casual as a family portrait at a special occasion or as formal as a group of executives for an annual report. Here, the photographer must be concerned not only with each person relates to the camera, but also with the relationships of the individuals to one another and how these interactions come across on film.

Ultimately, these special considerations should become one more element to be figured into your preplanning of the photographic session. The technical and compositional aspects of the shoot must be adjusted to reflect the unique aspects of the individual situation.

Head

Shot

The primary purpose of the head shot is to pictorially represent a model, an actor, or an actress. The shot is used as a remembrance, like a business card; but with these professionals, their commodity is their looks.

Since the sitter is selling appearance and personality, the head shot should be flattering and straightforward. Open, flat lighting—to avoid shadows—and a pleasant expression are essential ingredients. A light background, to aid the upbeat tone of the shot, is usually the case. I like to use a moderate telephoto (portrait lens) of between 85mm and 135mm with the 35mm format and between 120mm and 250mm with a 2¼″ square format. The lenses in these focal lengths tend to flatten the face and de-emphasize the nose, thus helping to flatter the sitter.

Open, flat lighting is achieved by using two umbrella lights pointed at the model from either side of the lens. One or two lights are used to illuminate the background, and occasionally a hair light is used to lighten the hair. The hair light is a spotlight that is pointed at the sitter's head from above and slightly behind. Fill-in reflectors are used on either side of the sitter and under the chin to further eliminate unwanted shadows.

LESLIE
KOPPEN

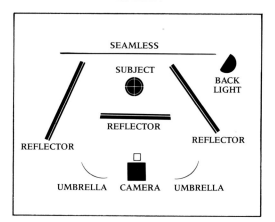

The photograph of Leslie Koeppen shows a model who has an engaging smile and who can relate back to the camera. With open light and a light color for the background and clothing, the general mood of the photograph is upbeat. The make-up was minimal to stress a clean, natural and uncomplicated look.

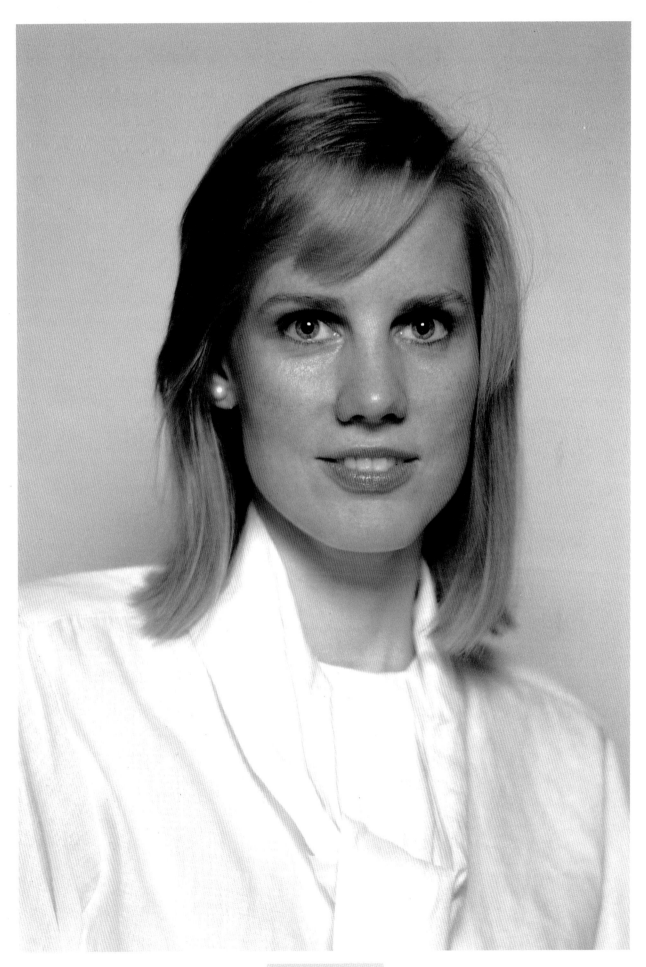

Some second choices show different looks within the same basic restrictions of what a head shot is.

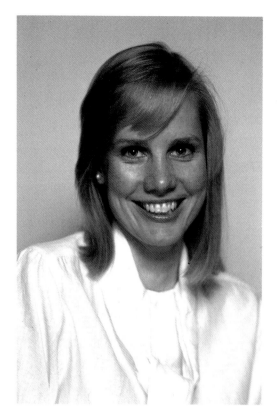

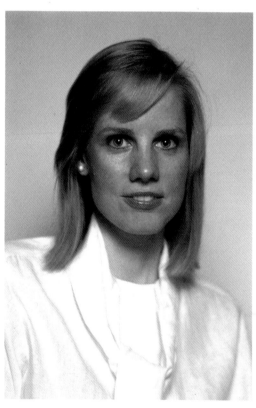

Although an increasing number of people request head shots in color, other people still prefer these portfolio pictures in black-and-white. The same principles of simplicity in lighting, pose, and expression apply to the black-and-white photographs as in color work.

Beauty

Shot

Like the head shot, the beauty shot is focused in on the model's face and shoulders. The beauty shot does, however, go further into the world of fantasy. It is usually used for a magazine article or advertisement featuring make-up or other "beauty" products. The photograph is selling the model's beauty and occasionally a fantasy about that beauty. Unlike the head shot, which is more natural, the beauty shot is more extreme in terms of make-up, pose, and expression. Many beauty shots are in fact about the make-up and should feature this fact through framing and lighting.

Using a moderate telephoto lens (85–135mm or 120–250mm) allows you to come in as close as possible to the subject's face and still maintain a flattering perspective. Lighting is similar to the head shot in that most times it will be a shadowless, broad light. On occasion, the lighting will be extreme. The deciding factor is based on the concept of the shot. The background is also dependent on the concept and can be as simple as a white seamless or as elaborate as a set requiring major construction.

The beauty shot is ultimately a fantasy and has a fashionable character. The sitter's personality is not a consideration, but beauty is. The photograph is based on the model's beauty and the fantasy that will be associated with it. In fact, a certain amount of anonymity is required, since the viewer will supply the fantasy.

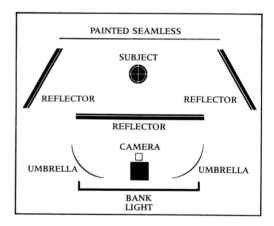

DEBRA
WORDWELL

In the photograph of Debra Wordwell, I was after a sophisticated beauty shot. The overall gold tone and the warm, abstract background might subliminally suggest the richness of a skin-care product.

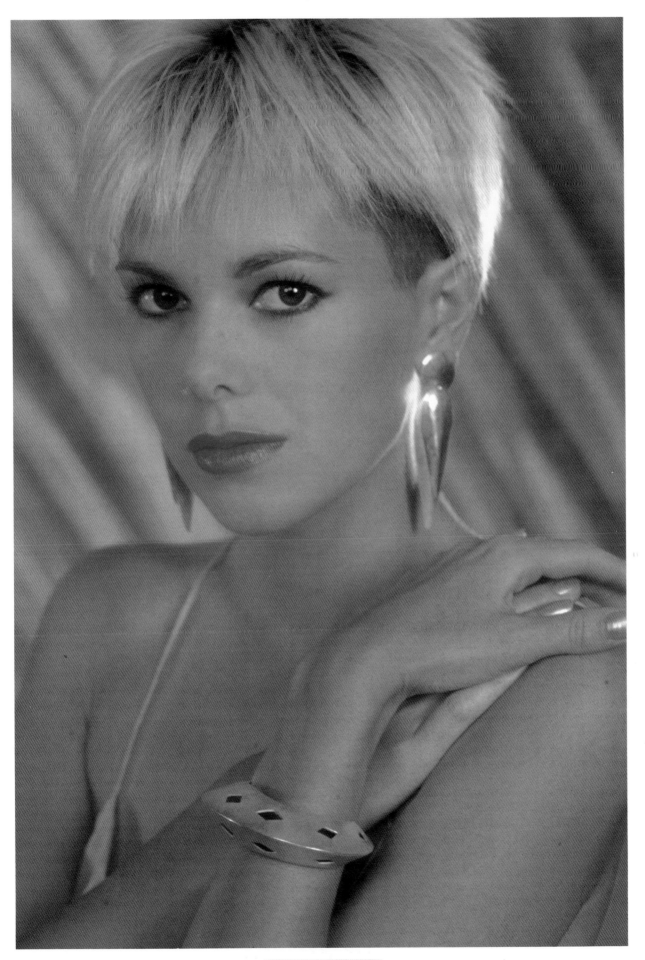

Executive

Portrait

The executive portrait is designed to show a powerful, successful person. The photograph may be used for different purposes —such as annual reports, company publications, or feature articles—but it is ultimately commissioned to flatter the executive by showing the strong points that contributed to the person's success. Therefore, the portrait should emphasize the person's individuality and the characteristics that helped that person rise to the top of his or her field.

Usually an environmental approach is best, as it can show the sitter in the context of specific accomplishments. When you're not allowed the enhancing characteristics of an environment, a successful way to show the sitter's power is through lighting that casts the sitter in a strong and dramatic role.

More often than not, the environment can and will be used. When this is the case, try to include the parts of the environment that best describe who and what your sitter is.

MARTIN DAVIS

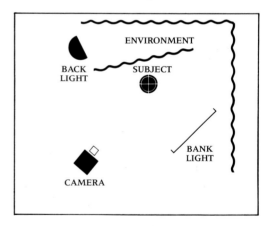

For this photograph of Martin Davis, chairman of the stockbrokerage firm D.H. Blair, I exploited the strong, dimly lit environment. I knew that I wanted a strong, powerful response from the sitter. I lit Mr. Davis with a bank light from the front to pull him away from the environment, but I allowed the interior to stay primarily dark, adding only a small light in the background. Prominently displayed on the desk is a copy of the book he authored. In his hands, Mr. Davis holds the black king from a chess set. These items reinforce the sense of Mr. Davis's stature. Other nuances, such as the hourglass and the crystal vase, moderate the sitter's stern look.

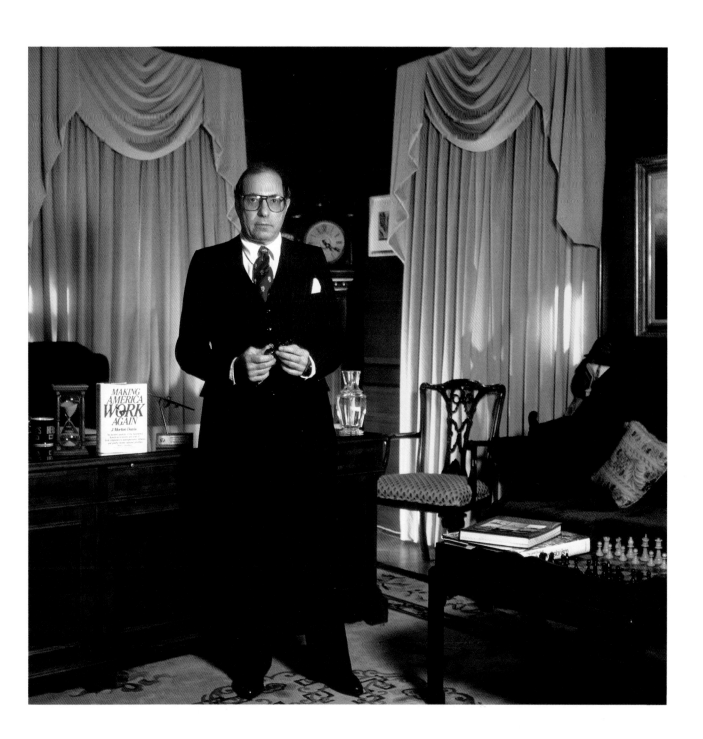

Child

Portrait

To photograph children, you must literally approach them on their own level. Never shoot down at a child; either lower the camera and lights to the child's level, or use a platform to raise the child to your normal camera level.

Children deserve the same consideration as anyone else you are photographing. This means you must plan out your concept and then work with the child to express his or her personality. The extra quality you need is patience, since most children have short attention spans. A relaxed photographer can go far when dealing with fidgety children. Photographers have various methods of putting children at ease. I may ask an older child to tell me a story, or I may try to amuse a younger child with a toy or with the novelty of the camera itself.

Lighting and background here, as in any other photograph, should fit the photographer's concept. Once set up, you may direct the sitter, but it is often best to relax, anticipate an expression, and catch it. With children, the key is to put them at ease, wait, and be ready when they are.

ALESSANDRA
MASCIANDARO

Alessandra Masciandaro and her bright cheeks remind me of Flemish vernacular painting, so I decided to set her up in this context. I used wrinkled canvas draped over a platform, so that the background texture would help interpret the light quality I was after. I placed my light at a 45-degree angle to Sandy's left side and used a matte red reflector on her right side. The reflector was used to help the shadow area go dark and warm. By using patience and anticipation, I was able to capture the pose I wanted.

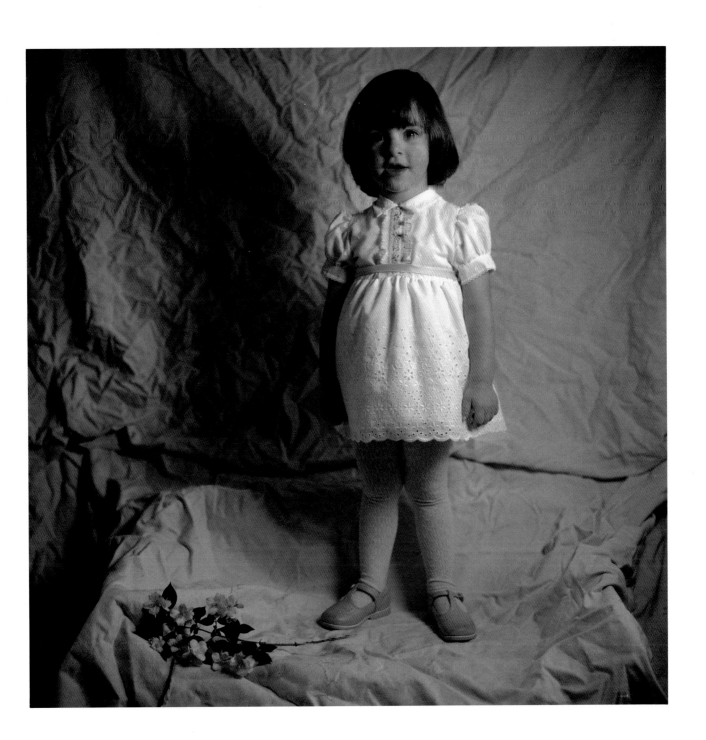

Family

Portrait

The idea of the family portrait is to depict the family as a unit while still describing some of the characteristics of each individual. I usually light a family photograph with a broad, diffuse light, so that everyone is illuminated equally. Occasionally, you might want to highlight one member of the family by keying the light to that person and allowing less light to fall on the other members, or by placing the prominent member in a forward position.

You want to stress the unity of the family, but it is equally important to realize each person's traits as an individual and to have these traits revealed in the context of the group. Each member can express individuality through his or her clothing, expression, and pose, and possibly through the use of a prop. You might want to have the fisherman of the family hold a "fly," for example, or have the tennis player hold a racquet.

After you've defined the individuals, you must define them as a family. The lighting, the placement of the individuals, and the interaction conveyed by each person's pose and expression should reflect that they are part of the same family.

THE CASSIDY FAMILY

Dennis Cassidy is a carpenter and craftsman who has a deep affection for music. He also has a strong understanding of the concept of "family" and believes in it wholeheartedly. His wife Cecilia is the quintessential mother. I grouped Dennis, Cecilia, and their children around their piano in order to show the family as one whose members are in harmony both literally and figuratively. The children—Megan, Patrick, and Katie—are grouped according to their age, perhaps to show the room for growth within a creative environment that has traditional ground rules established. The grouping shows the closeness, understanding, and interrelationships of a cohesive unit.

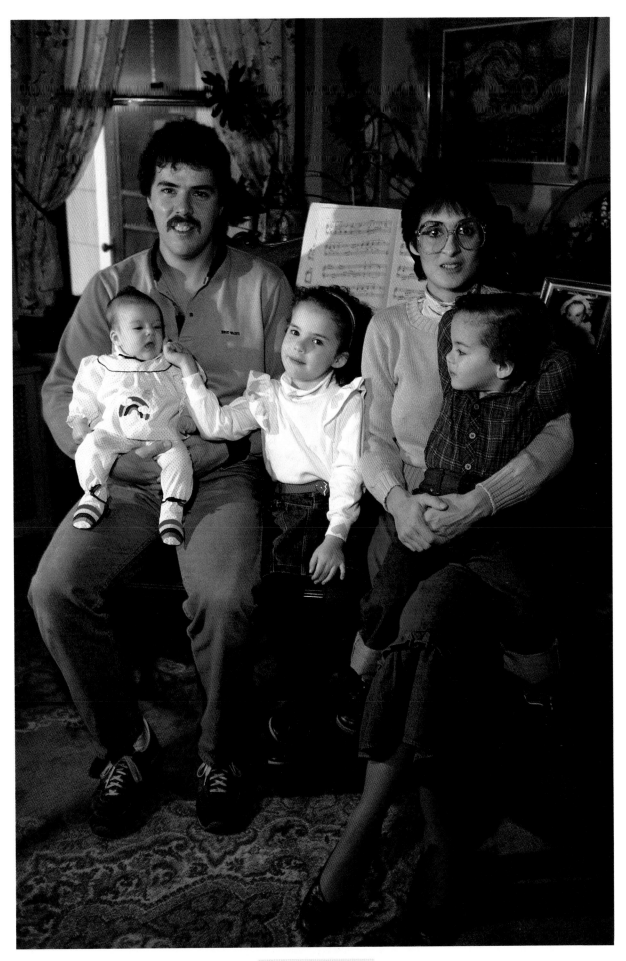

Group

Portrait

The group portrait is similar to the family portrait, except that the common bond among the individuals is not the family but a job, a hobby, or some other factor. As with the family portrait, we want to define the individual within the context of the group. The sum of the parts makes up the whole.

 The best approach to a group photograph is to find the common thread amongst the individuals and to define it through the use of setting, clothing, props, and lighting. To define the common thread is to tell the story of the group.

 Once the common bond has been defined, the importance of individual subjects can be made clear by pose and placement within the group. No one person should actually overpower the others. Each should be shown in terms of the group, with minor variations to show individual stature.

BOBBY ORDAZ,
REINALDO MOLINO,
AND RICHARD BORCK

This portrait was commissioned to show a master fabric printer with his assistant and his apprentice. By including the printing press, I've defined these men's jobs as their common bond. By placing the master printer, Bobby Ordaz, slightly forward and to one side of the others, I emphasized his position as the leader. The assistant, Rienaldo Molino, placed with his hand on the machine, gains secondary importance. The apprentice, has a background position.

 Lighting was a frontal bank light with ambient light as fill-in. The front light opens up our view to the sitters. The background and props go slightly darker, further emphasizing the people.

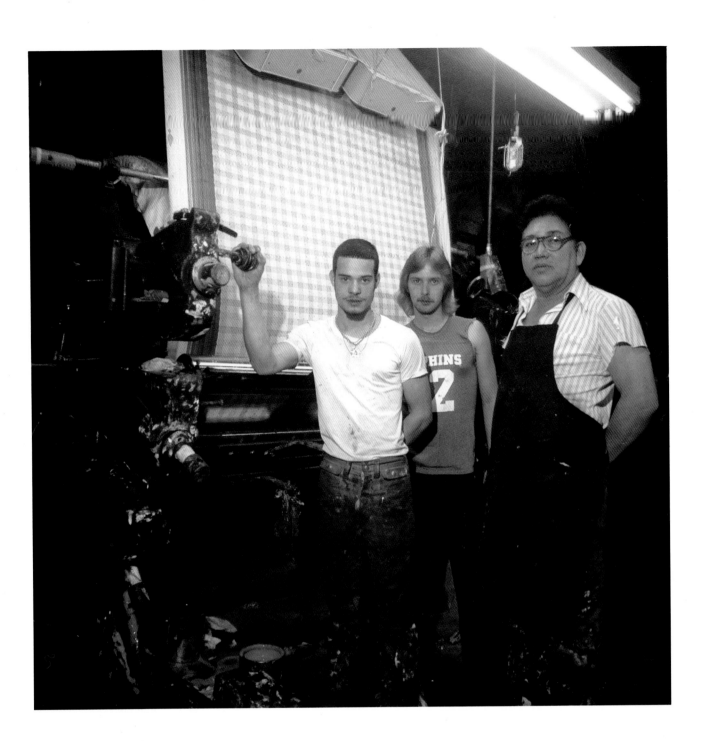

Self-
Portrait

When the artist photographs himself, there is a dichotomy of interests. As the sitter, you want to create a favorable impression of yourself. As the photographer, you want to create a truthful image of the sitter. In this situation, the photographer has to remain true to his artistic principles and not vary them to meet personal wishes. Artistic integrity is tested to the fullest, but any alteration in that integrity can lead to a breakdown in the believability not only of that one photograph but of the entire body of the artist's work.

The photographer must realize that a self-portrait is only one photograph in a unified body of work. That work reflects the artist's criteria and skills; so, in a sense, all of the work reflects a bit of the photographer. Basically, however, the photographer does not let personal feelings interfere with an objective interpretation of who the sitter is.

The self-portrait allows the photographer to explore and convey his own individuality in a neutral way. It reveals that the sitter has to have at least as much input as the photographer.

VINCENT
COLABELLA

I'm rarely without my Yankee hat, and it may be for two reasons. The first is what the hat represents, since I am an avid fan. The second is that my eyes are quite sensitive to light and the beak blocks out the light. I thought it appropriate to photograph myself with the Yankee hat shading my eyes.

I also tend to be secretive about part of my life. Perhaps the photographer in me is so powerful that I wish to exploit mystery and not delve into the personality of the other self. Accordingly, the lighting, a window light at a 45-degree angle to one side, leaves part of my face in the dark.

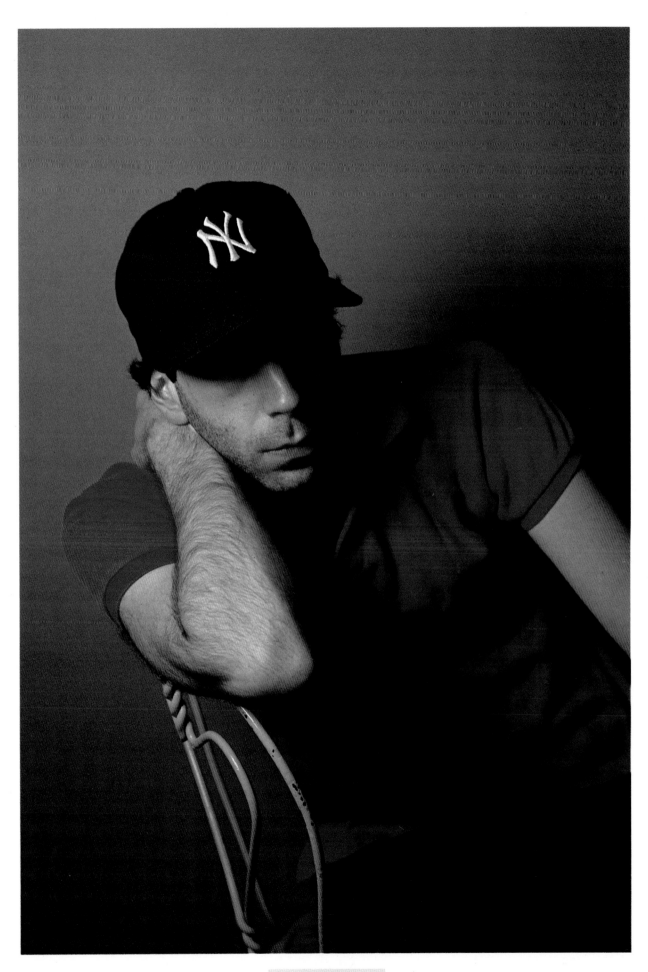

7

Your portfolio is your calling card as a photographer. The format that you choose should present your work in an attractive manner that is accessible to the viewer. Large prints, properly mounted and placed in an artist's case, are probably the easiest way to show your work to prospective clients.

DEVELOPING
A PORTFOLIO

The portfolio represents the artist; it should include the artist's best work, and it should be presented in an easily manageable form.

Putting prints of your work in a book form seems to be a good technique. Prints provide a pleasing and convenient way to look at most photography. They are a good size, and they can be studied under normal viewing conditions. Slides in sheets make your work look small, and they require a magnifier and light box for viewing. Slides in a projector tray yield enlarged images but require more elaborate viewing equipment.

Developing a portfolio, though, requires more than just taking your photographs and putting them in a booklet. The portfolio has to have a continuity. You must show consistency as well as flexibility. A photographer showing his work is like someone in another field submitting a resume. The entries must show a logical progression. The premise of the portfolio is not as reliant upon the mode of presentation as it is upon the content of the presentation.

The content of a portfolio, like that of a book, should tell a story, a story not only about the sitters but about the photographer. Who is he? How does he portray his sitters? How much objectivity does he employ, and what artistic merit is there to the work? The photographer must excite the viewer, and keep him excited page after page. The excitement should grow. The viewer should turn each page with anticipation. Ultimately, the portfolio is like a good mystery—adding clues, building upon a theme, and always keeping the viewer glued to the images.

Personal

Style

Your style is the look you give to your photographs, your signature. As you develop as an expressive artist, your personal style will emerge. Your style and technique is what your clients will buy; it is what will make you different from the next person. I can't tell you how to develop your own distinctive quality, but I can express to you some considerations.

Some type of artistic sensibility is required. The mere use of gimmicks, such as muted color, grainy film, and light flaring, will not create an artistic work. You must first learn to apply the basic concepts of art; then if certain equipment or materials are helpful, use them as an aid. It is your intellect, not your equipment, that ultimately creates art.

A photograph is judged in terms of its lighting, composition, and intellectual content. We've talked about lighting and composition and, to some extent, about intellectual content. The intellectual content is the social message of the photograph. The portrait does more than state the sitter's physical features and possibly his or her profession. It defines the sitter's character and indicates that person's relationship to society. You must objectively show the viewer the kind of person the sitter is. To do this, you must examine yourself as well as the sitter.

My own work emphasizes a sharp, clear image with the frame packed with as much information as possible. I'm always careful to design the contents of the frame so that they have a stated meaning and don't appear as random offerings.

To develop one's own methods and style requires investigation and experimentation. Try different techniques until you are satisfied with a basic formula. Once you devise a basic formula, stay with it, develop it, and expand on it.

Consistency is one of the largest factors in determining a photographer's style. But a specific "look" does not develop overnight. The way you light a photograph, your choice of compositional elements, all work together in establishing your style. If you aim for the best in every photograph you take, your style will begin to emerge over a period of time.

I like to keep my mind and hands active; even when I'm not photographing, I'm planning out visual ideas for new pictures. I always keep a small notebook handy to quickly sketch out my plans.

Special

Projects

I believe in keeping the mind and hands active by exploring new avenues. When not commissioned, I work on projects of my own design. I assign myself a project with parameters; and within an unspecified amount of time, since commissioned work will take precedence, I will complete these projects. I have in the past assigned myself to photograph artists, and I am currently attempting to photograph the New York newspeople.

Assigning yourself a project will challenge both your creativity and your commitment to your work. First of all, it is necessary to be totally involved in your project if you are to be successful with it.

This sample letter
shows how I write to a
potential sitter. I am
sure to state my inten-
tions and credentials.

Dear

I am a photographer who specializes in Portraiture. I believe my work to be of a highly artistic nature for nearly 15 years. My education was at Pratt Institute and I have been photographing for nearly 15 years. I am currently has been shown in galleries and has been publishing the New York news people. To date I have photographed Gene Shalit, Bryant Gumbel, Dave Willard Scott, John Hambrick, Chauncey Howell, Pia Lindstrom and Dave Marash. I would like to continue with my project and photograph you. All I need is approximately 10 minutes of your time at your convenience. I will photograph you on location in your environment or at my studio, whichever you prefer. For your time and help in this project, I will give you a finished matted print. Thank you in advance for your consideration.

Very truly yours,

Vincent Colabella

But when you are totally immersed in your work, you can begin to explore the boundaries of its potential creativity. If you shoot only occasionally, you're not capable of drawing upon past work, because it becomes too distant; instead, you tend to merely repeat it. By continually working, you grow; and with this growth, your work gains greater intelligence.

Assigning yourself a project means setting a goal and designing a plan to reach that goal. The project provides an opportunity to explore the creative means to an end and to produce a statement more encompassing than one produced by a random collection of photographs.

Any project requires a diligent work ethic. Set up a concept with attainable goals and the execution occurs. The execution relies on contacting potential sitters, explaining your project, and arranging the time to photograph. The final and most important step is to do the work.

The unrelentling photographer works with passion, as if on a mission. The exploration and furthering of his work is the driving force. The difference between artist and worker is the total dedication the artist has. The driving force should not be financial compensation but the creation of new concepts.

Editing

the

Work

When you watch a movie, you will notice that a good editing job will enhance the character of the movie. The editing is essential to the flow and understanding of the director's motives. In still photography, the editing process plays just as important a role. When editing, I look at the entire series of photographs and pick the one image that best tells the story of the sitter.

Editing is the final process in executing your concept. There is always one image that fits your concept perfectly. In editing, you select the one obvious choice—the culmination of lighting, framing, pose, and moment.

If you decided to photograph your sitter with low-key lighting and a sullen expression, then the edit should find that image. The image you pick shouldn't be of a happy, laughing subject. You want your preconceived look.

You look at all the images together, either on a contact sheet or as chromes on a light box. You are looking for the best solution to the original concept. When you have a few very similar images, you have to look more closely at the subtle nuances. These minor nuances, which you might not even have seen while shooting, may now play an important part in your final choice. The pleasant surprises—the bent finger, the raised eyebrow, the Pepsi can, and so on—can be significant.

I don't believe in overshooting and then relying on the edit to find the image. I do believe in carefully planned shootings and an edit that enhances the message to the viewer.

By placing all of the choices on a light box, the photographer begins to choose the best shot and to discover the subtleties of the various images. The slides here are of Father Michael Mullen in two different situations—one outdoors and one indoors. From these slides, I chose the situation and then the particular image that I thought best told the story.

My original plan was to photograph Father Michael Mullen outside a chapel. When I arrived, Father Mullen told me that he was a radio operator and that maybe I should take some photographs in his office. After we shot my original concept, we went to his office, and I photographed Father Mullen with his radio.

As I was editing, I began to notice that my second situation was actually more telling. Father Mullen as a ham operator would convey more to the viewer. His collar indicates he is a priest so the radio adds a new dimension.

The editing showed which situation to choose. I still had to pick the best photo-

graph in that series. I wanted to reveal Father Mullen's personality as well as his occupation, vocation, and hobby. To this end, I chose a photograph of Father Mullen presenting himself straight on to the camera and using the radio as a prop, not as an essential item as some other shots showed.

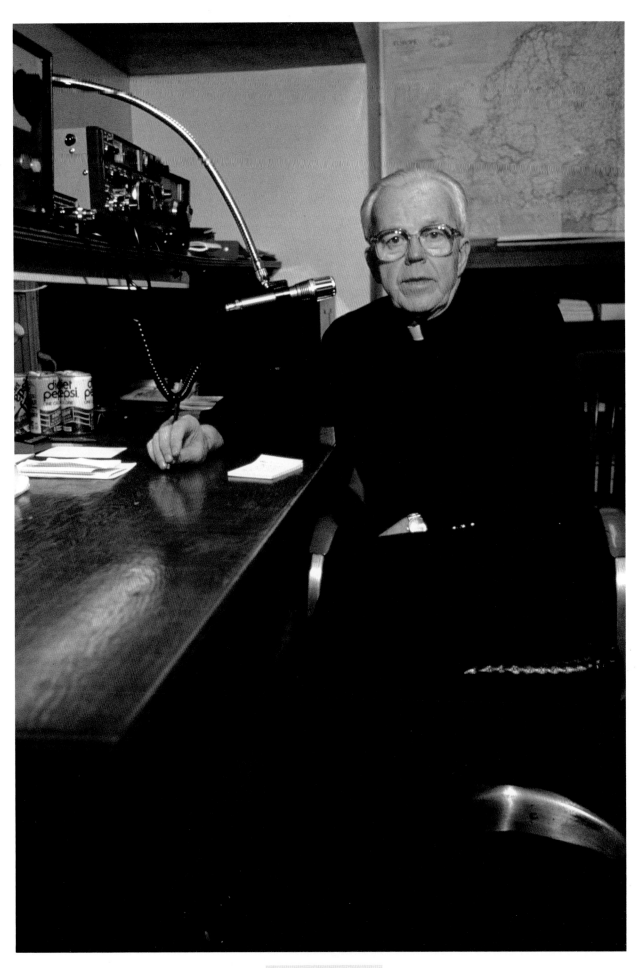

Index